D0988425

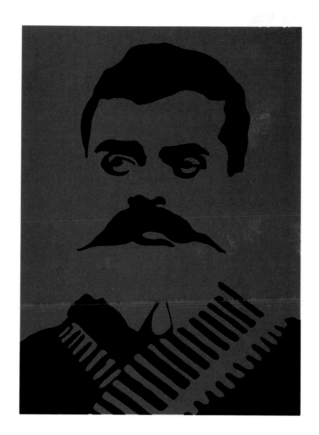

Donated to

**Visual Art Degree
Sherkin Island**

¡LIBERTAD PARA LOS
PRISONEROS POLITICAS!

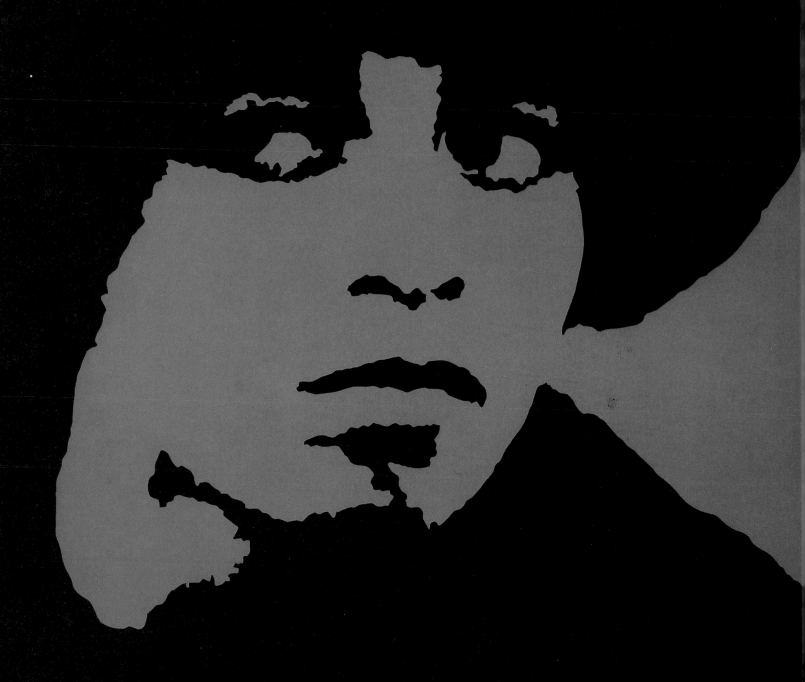

Rupert García

Prints and Posters
1967–1990

Grabados y Afiches
1967–1990

The Fine Arts Museums of San Francisco

Centro Cultural/Arte Contemporáneo and

Fundación Cultural Televisa, A.C.

Distributed by Northeastern University Press, Boston

Rupert García
Prints and Posters 1967–1990
Grabados y Afiches 1967–1990

The Fine Arts Museums of San Francisco
California Palace of the Legion of Honor
8 December 1990–3 March 1991

Centro Cultural / Arte Contemporáneo
Mexico, D.F.
April–June 1991

Whatcom Museum of History and Art
Bellingham, Washington
31 August–27 October 1991

Joslyn Art Museum
Omaha, Nebraska
1 October–29 November 1992

This exhibition has been co-organized by The Fine Arts Museums of
San Francisco and the Centro Cultural / Arte Contemporáneo and
Fundación Cultural Televisa, A.C. The partial sponsor for the exhibition in
San Francisco is the AT&T Foundation.

This catalogue is made possible through the generous support of the Centro
Cultural / Arte Contemporáneo and Fundación Cultural Televisa, A.C.,
Mr. and Mrs. Robert Marcus, Rena Bransten, and with the assistance of
The Andrew W. Mellon Foundation Endowment for Publications.

Photo credits: Cat. nos. 12a, 15a, 16, 20, 33, 38, 42, 70, 83, 91, 99, and figs. 1, 2,
and 3 by Phillip Hofstetter. Cat. nos. 24 and 75b by Ben Blackwell. All others
by M. Lee Fatherree.

Library of Congress Catalogue Card No. 90-084598
ISBN 0-88401-069-4

Distributed by Northeastern University Press, Boston.

Produced by the Publications Department of The Fine Arts Museums of
San Francisco. Designed by Marquand Books, Inc., Seattle.
Display type: Clarendon. Text type: Primer. Paper: 157 New Age.
Printing by Toppan Printing Co., Ltd.

Front cover: Cat. no. 103, *Frida Kahlo*, 1990
Back cover: Cat. no. 104, *The Silver Dollar*, 1990
Page one: Cat. no. 7, *Zapata*, 1969
Frontispiece: Cat. no. 30a *¡Libertad para los Prisoneros Políticas!* 1971
Title: Cat. no. 47a, *Maquey de la Vida*, 1973
Contents: Cat. no. 43 *¡Cesen Deportación!* 1973

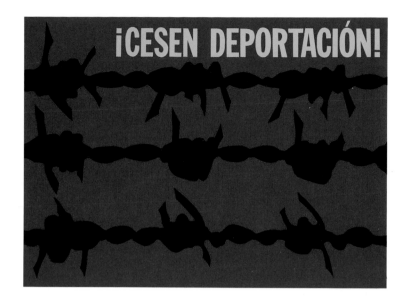

Contents

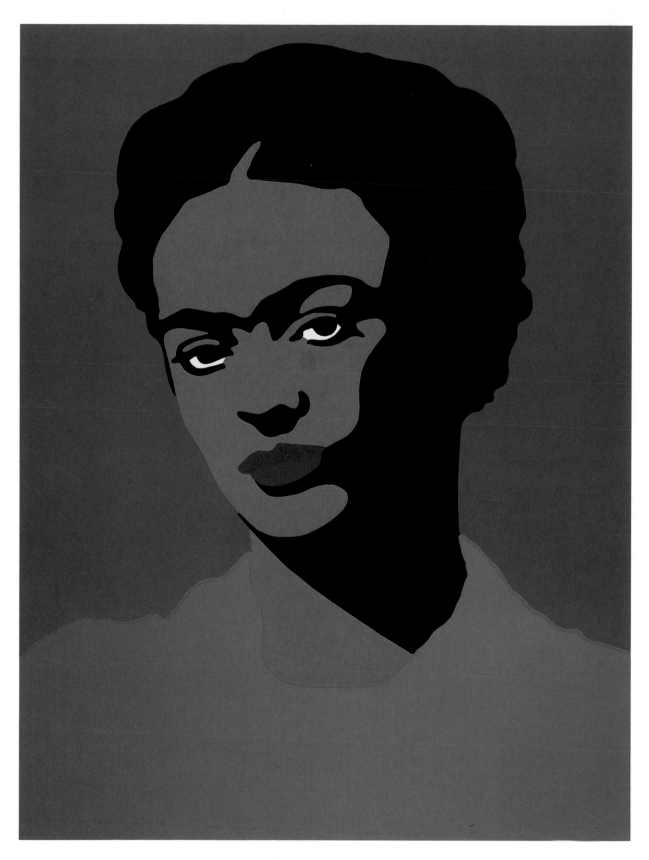

Frida Kahlo, 1975 (cat. no. 57)

Directors' Foreword

The Fine Arts Museums of San Francisco and the Centro Cultural/Arte Contemporáneo and Fundación Cultural Televisa, A.C., are pleased to present the first comprehensive survey exhibition of the prints and posters of Rupert García, one of the most acclaimed Mexican American artists in the United States. The exhibition includes seventy silkscreen prints, posters, etchings, and lithographs created from 1967 to the present. The works in the exhibition have been selected from the collection of the Achenbach Foundation for Graphic Arts, which contains an archive of the artist's prints and posters.

Rupert García first became known for his political posters during the late sixties and early seventies when he was active in student and Mexican American/Latino cultural movements. Working primarily with silkscreen technique, he developed a bold style, appropriating many of the pictorial devices and premises of Pop Art, but subverting them from a Mexican American and Third World perspective to serve his own aesthetic and ideological ends.

Much of Rupert García's graphic work is clearly intended to challenge the viewer's social and political perspective. His themes are universal—the struggle for human rights and for economic, social, and political justice. With refined technical skills and unusual sensitivity, García eloquently demonstrates the necessity for thinking critically about the human condition.

It is a pleasure to have our museums from separate countries join in the organization of this important traveling exhibition. In addition, the accompanying catalogue will remain as an important reference work on the artist that will function as a catalogue raisonné of his graphic work. In the spirit of cooperation between our two cultures, the essays have been published in both English and Spanish.

This exhibition and catalogue could not have taken place without the generous financial support of

Prólogo de los Directores

The Fine Arts Museums of San Francisco y el Centro Cultural/Arte Contemporáneo y Fundación Cultural Televisa, A.C., tienen el honor de presentar la primera exhibición comprensiva en perspectiva de los grabados y afiches de Rupert García, uno de los más reconocidos artistas méxico-americanos en los Estados Unidos. La exhibición incluye setenta trabajos de serigrafías, afiches, grabados en aguafuerte, y litografías creados desde el año de 1967 hasta el presente. Los trabajos de arte incluidos en la exhibición han sido seleccionados de la colección de la Achenbach Foundation for Graphic Arts, la cual contiene un archivo de los grabados y afiches del artista.

Rupert García ha sido reconocido primeramente por sus afiches políticos durante los últimos años de la decada de los sesentas y los primeros años de los setentas, cuando él era un activista en el movimiento estudiantil y en el movimiento artistico méxico-americano y latino. Trabajando primeramente con la técnica de la serigrafía, él desarrolló un estilo muy atrevido, apropiandose de muchas de las invenciones pictóricas y premisas del Arte Pop, pero a la vez subvertiendolas hacia una perspectiva méxico-americana y tercermundista para así servir sus propios objetivos estéticos e ideológicos.

Muchos de los trabajos gráficos de Rupert García están claramente diseñados con la intención de crear un reto a las perspectivas políticas y sociales del espectador. Sus temas son universales—la lucha por los derechos humanos y por la justicia económica, social y política. Con sus refinadas habilidades técnicas y una sensitividad muy fuera de lo usual, García demuestra elocuentemente la necesidad de pensar críticamente acerca de la condición humana.

Es un placer el que nuestros dos museos, en diferentes países, se unan en los esfuerzos organizativos de esta importante exhibición rodante. Además, el catálogo que le acompaña, permanecerá como un

the AT&T Foundation, Mr. and Mrs. Robert Marcus, Fundación Cultural Televisa, A.C., and Rena Bransten. Numerous individuals worked extremely hard to make this exhibition a success. Anne Kohs has been supportive at every stage. Robert Flynn Johnson and Judith Eurich were instrumental in the organization of the exhibition. Lucy Lippard has written a thought-provoking essay that clearly places García's art within the context of our time. Ed Marquand is to be thanked for the handsomely designed exhibition catalogue, and Carlos Córdova for translating the catalogue text from English into Spanish. In addition, we are grateful to Jane Curliano, Armelle Futterman, and Siobhan Murphy of Anne Kohs & Associates, and to Niccolo Caldararo, Therese Chen, Susan Goldsmith, Ann Karlstrom, Karen Kevorkian, Paula March, Debra Pughe, Maxine Rosston, and the staff of the Western Regional Paper Conservation Laboratory of The Fine Arts Museums.

Special appreciation goes to Mr. and Mrs. Robert Marcus for their generous donation of the archival collection of Rupert García's graphic works to the Achenbach Foundation for Graphic Arts. Their gift ensures that his work will always be available to inspire future generations in the Bay Area.

Finally, our thanks are extended to Rupert García for his patience and enthusiasm. He is an artist/activist who has chosen the beauty of art as his message for change. It is gratifying that this exhibition will spread the knowledge of his unique talent to a wider audience in two great nations.

Harry S. Parker III, Director
The Fine Arts Museums of San Francisco

Robert R. Littman, Director
Centro Cultural/Arte Contemporáneo
Mexico, D.F.

importante trabajo de referencia en el artista y a su vez funcionará como un catálogo comprensivo de sus trabajos de artes gráficas. En el espíritu de cooperación entre nuestras dos culturas, los ensayos han sido publicados simultaneamente en inglés y en español.

Esta exhibición y catálogo no se hubieran podido realizar sin el generoso apoyo económico de la AT&T Foundation; el Sr. Robert Marcus y Sra.; la Fundación Cultural Televisa, A.C.; y Rena Bransten. Numerosas personas han trabajado a un nivél sumamente alto para que esta exhibición sea todo un éxito. Anne Kohs ha prestado mucho apoyo en todos los niveles. Robert Flynn Johnson y Judith Eurich fueron instrumentales en la organización de esta exhibición artística. Lucy Lippard ha escrito un provocador ensayo que claramente coloca al arte de García dentro del contexto de nuestros tiempos. Muchos agradecimientos se le dan a Ed Marquand por el diseño muy atractivo de el catálogo de esta exhibición, y al Dr. Carlos B. Córdova por la traducción de el texto del catálogo del inglés al español. Además, estamos muy agradecidos de Jane Curliano, Armelle Futterman, y Siobhan Murphy de la compañia Anne Kohs y asociados, y a Niccolo Caldararo, Therese Chen, Susan Goldsmith, Ann Karlstrom, Karen Kevorkian, Paula March, Debra Pughe, Maxine Rosston, y el Western Regional Paper Conservation Laboratory de The Fine Arts Museums of San Francisco.

Un agradecimiento muy especial es dedicado al Sr. Robert Marcus y Sra. por su generosa contribución del archivo de su colección de trabajos gráficos de Rupert García a Achenbach Foundation for Graphic Arts. Su donación nos asegura que su trabajo estará siempre disponible para inspirar a las futuras generaciones en el área de la bahía de San Francisco.

Finalmente, nuestros agradecimientos son extendidos a Rupert García por su paciencia y entusiasmo. Él es un artista y activista quien ha escogido la belleza del arte para difundir su mensaje en busca de los cambios sociales. Es muy satisfactorio saber que esta exhibición logrará difundir las habilidades de su talento sin igual a una audiencia muy extensa en nuestras dos grandes naciones.

Harry S. Parker III, Director
The Fine Arts Museums of San Francisco

Robert R. Littman, Director
Centro Cultural/Arte Contemporáneo
México, D. F.

The Composition of Conscience

La Composición de la Conciencia

Beauty, like truth, is relative to the time when one lives and to the individual who can grasp it.

-Gustave Courbet[1]

Through the forceful beauty of his art, Rupert García distills deeply held social and political beliefs into a personal yet truthful mirror of the times through which he has lived. In his prints and posters García has bridged the usually uncrossable chasm between a truly accessible art for the people and compositional and artistic sophistication.

One of the most surprising and disturbing aspects of the vast majority of avant-garde United States art of the past thirty years is its nearly total denial of our society's tumultuous social and political journey. With few exceptions, it would be impossible to recognize from walking through most museums today that the United States had gone through the Civil Rights Movement, the Vietnam War, Women's Liberation, and other significant social transformations. The galleries are, by and large, filled with works of art of a decorative, intellectually formal nature. Abstract designs, shapes, and gestures predominate. When subject matter appears it is often in the extremes of highly personal or impersonal imagery, maintaining a socially or politically neutral or at least highly ambiguous stance. Is, for example, Warhol deifying or ridiculing such celebrities as Marilyn Monroe and Elizabeth Taylor in his art? It all depends on the viewpoint of the intellectual rhapsodizing over its content. It is an art that elicits a Rorschach test of fashion, class, and style. Provocative but passionless, much of this art leads to emotional sterility. This is not the case with Rupert García. García's art is forged by his heart and tempered by his mind. There is a clarity and consistency to his message that is at odds with the hip ambiguity of our age.

García is not only true to himself, he is true to his era. Picasso wrote in 1923, "Velásquez left us his idea of

La Composición de la Conciencia

La belleza como la verdad es relativa al tiempo en que uno vive y al individuo que puede tomarla en sus manos.

—Gustave Courbet[1]

Rupert García destila sus profundos sentimientos sociales y políticos a través de una belleza forzada en su arte hacia un espejo personal y a la vez realista de los tiempos en que él ha vivido. En sus trabajos gráficos y en sus afiches, García ha creado un puente entre los usualmente impasables precipicios que existen entre el arte que es verdaderamente accesible al pueblo y el refinamiento del arte y su composición.

Uno de los más sorprendentes y disturbantes aspectos de la gran mayoría del arte avant-garde de los Estados Unidos en los últimos treinta años, es la negación, casi en su totalidad, de la tumultuosa travesía social y política de nuestra sociedad. Con muy pocas excepciones, sería imposible llegar a reconocer, al caminar en estos días por la mayoría de museos, de que los Estados Unidos hayan pasado por el Movimiento de los Derechos Humanos; la Guerra de Vietnam; el movimiento de Liberación de las Mujeres; y otras transformaciones sociales de gran importancia. Las galerías son y estan repletas de obras de arte de una naturaleza decorativa, é intelectualmente formalizada. Diseños, formas, y gesticulaciones abstractas son muy predominantes. Cuando los temas son representados, es usualmente en los extremos de conjuntos de imágenes de una naturaleza altamente personal ó impersonal, que se mantienen socialmente ó políticamente neutrales, o por lo menos, mantienen una posición altamente ambigua. Por ejemplo ¿estaba Warhol tratando de deificar ó de ridicular a personajes célebres como Marilyn Monroe y Elizabeth Taylor en su arte? Todo esto depende del punto de vista del intelectual que atraviesa toda una rapsodia sobre su contenido artístico. Es un arte que nos confronta con un test Rohrschach de la moda, clase y de estilo. Provocativamente, pero sin ninguna pasión, la

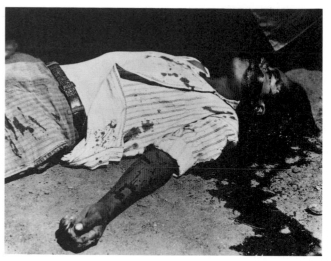

Fig. 3. Manuel Alvarez Bravo (Mexican, b. 1902), *Worker on Strike, Murdered* (Obrero en Huelga, Asesinado), 1934. Silver print. Reproduced by permission of the artist.

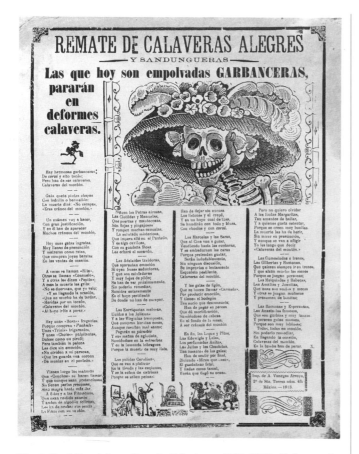

Fig. 1. José Guadalupe Posada (Mexican, 1851–1913), *Calavera de la Catrina*, 1913. Relief etching on zinc, 343 × 252 mm. The Fine Arts Museums of San Francisco, Achenbach Foundation for Graphic Arts, Gift of George Hopper Fitch, 1983.1.60.

Fig. 2. José Clemente Orozco (Mexican, 1883–1949), *Three Generations* (Tres Generaciones), 1926. Lithograph, 265 × 375 mm. The Fine Arts Museums of San Francisco, Achenbach Foundation for Graphic Arts, Gift of Mr. and Mrs. George Hopper Fitch, 1976.1.478.

Fig. 4. Rupert García, *Assassination of a Striking Mexican Worker*, 1979. Pastel on illustration board, 113 × 160 mm. Collection of Fred and Jo Banks.

mayoría de estas formas de arte nos llevan a una esterilidad emocional. Este no es el caso de Rupert García. El arte de García está forjado con su corazón y está templado a través de su mente. Hay una claridad y consistencia en su mensaje que está en desacuerdo con la ambigüedad que está de moda en nuestra época.

García no es solamente sincero con sí mismo, él es sincero con su época. Picasso escribío en 1923, "Velásquez nos dejo su idea de la gente de su época. Sin ninguna duda, ellos fueron diferentes de como él los pintó, pero nosotros no podemos concebir a Felipe IV de ninguna otra manera que no sea en la que Velásquez lo pintó a él."[2] Esta es la realidad de García. Cuando uno mira de regreso a los años sesenta y los setenta en busca de un sentido de veracidad acerca de la realidad y de su lugar en la historia, se puede buscar esa realidad en los

the people of his epoch. Undoubtedly they were different from what he painted them, but we cannot conceive a Philip IV in any other way than the one Velásquez painted."[2] It is also true of García. When one looks back to the sixties and seventies for a sense of veracity for that time and place, it is the subject matter, bold design, and vivid color of García's posters and prints that ring true. The works were timely then as messages to the people; they are timeless now as works of art that still retain their moral conviction.

The passionate advocacy of García's art is part of a continuity that stretches far back in Mexican art from the popular relief-print broadsides of José Guadalupe Posada (fig. 1), to the works of Diego Rivera, Frida Kahlo, David Alfaro Siqueiros, and José Clemente Orozco (fig. 2). García is not afraid to recognize and utilize powerful preexisting imagery. For example, in the case of the famous 1934 photograph by Manuel Alvarez Bravo, *Obrero en Huelga, Asesinado* (fig. 3), through the use of color and abstracting of the image García transformed this photograph into his own artistic message (fig. 4). A poignant and powerful image of one era has been given new life and relevance in our own.

Despite the often serious content of García's art, it is far from being dour or distancing. On the contrary, García's posters and prints, vibrant in color and composition, demand attention. The full range of human emotion from laughter to grief is explored in these works. The art world is fortunate to have an artist such as Rupert García in its midst, who examines and reflects upon the issues of our turbulent times. He proves that even in our modern society art still has the power to move emotions and heighten our awareness of the world around us.

Robert Flynn Johnson
Curator in Charge
Achenbach Foundation for Graphic Arts
The Fine Arts Museums of San Francisco

Notes

1. *Artists on Art*, compiled and edited by Robert Goldwater and Marco Treves (New York: Pantheon Books, 1947), p. 296.

2. *Artists on Art*, p. 417.

temas, los intrépidos diseños, y los colores vividos de los afiches y grabados de García. Ellos sirvieron en su tiempo como mensajes al pueblo. Ahora, sin las limitaciones del tiempo, son trabajos de arte que continuan manteniendo sus convicciones morales.

La abogacía apasionada del arte de García es parte de una continuidad que viene desde muy atrás en el arte Mexicano, desde los panfletos gráficos populares de José Guadalupe Posada (fig. 1) hasta los trabajos de Diego Rivera, Frida Kahlo, David Alfaro Siqueiros, y José Clemente Orozco (fig. 2). García no tiene miedo de reconocer y utilizar las poderosas imágenes ya existentes. Por ejemplo, así es el caso de la famosa fotografía de Manuel Alvarez Bravo, *Obrero en Huelga, Asesinado* (fig. 3), a través del uso del color y la abstracción de la imagen, García transformó esta fotografía a su propio mensaje artístico (fig. 4). Una punzante y poderosa imagen de otra era ha recibido una nueva vida y relevancia propia.

A pesar del frecuente contenido serio del arte de García, este no crea un distanciamiento de el que lo mira. Al contrario, los afiches y trabajos gráficos de García, vibran en sus colores y composición, ellos demandan la atención. El espectro total de las emociones humanas, desde la risa hasta el sufrimiento han sido exploradas en sus obras de arte. El mundo del arte tiene la gran fortuna de tener un artista tal como Rupert García en su medio, el cual examina y refleja sobre las realidades de nuestros tiempos turbulentos. Él ha probado que aún en nuestra sociedad moderna, el arte siempre tiene el poder de mover las emociones y elevar nuestras percepciones del mundo que nos rodea.

Robert Flynn Johnson
Conservador en Cargo
Achenbach Foundation for Graphic Arts
The Fine Arts Museums of San Francisco

Notas

1. *Artistas en Arte*, editado y compilado por Robert Goldwater y Marco Treves (Nueva York: Pantheon Books, 1947), p.296.

2. *Artistas en Arte*, p. 417.

Attica is Fascismo, 1971 (cat. no. 31a)

L U C Y R . L I P P A R D

Rupert García

Face to Face

Like so many of us who are involved in the ongoing project of mixing up new recipes for art and politics, Rupert García is a "child of the sixties." This is not to say he is "old-fashioned," but that he maintains the hopes and values of that raucous, often satisfying, often saddening time, which marked the intensification of anti-imperialist Third World struggles everywhere.[1] He has never lost his anger—and during the eighties there was every reason to maintain it—but over the years he has deepened and broadened its products. Today an overview of García's lifework is marked by anticipation rather than nostalgia. In the mid-eighties, his pastel diptychs and triptychs opened a whole new series of possibilities for both form and content that should keep him busy for a long time.

Such anticipation necessarily affects the way I look back. This show focuses on García's prints and posters, most of which were made between 1967 and 1975, in the eye of so many hopeful radical storms. But they cannot be separated from the pastels and paintings that have accompanied and complicated many of the same images over the last fifteen years. In this genuinely declarative art, style and content are interdependent. The multiple work is done squarely in the center of social contexts, and is distilled to catch the eye, touch the heart, or engage the conscience. The one-of-a-kind work (like the recent lithographs) is further evidence of the artist's respect for the political issues and images he addresses. García knows what he sacrifices for public clarity in the distilled versions, and he cares enough to keep delving into it, juxtaposing the poster images against others or each other until different and subtler sparks fly.

Cara a Cara

Así como muchos de nosotros que estamos involucrados en el presente proyecto de mezclar nuevas recetas para el arte y la política, Rupert García es un "producto de la década de los sesenta." Esto no significa que Rupert está pasado de moda," sino que él mantiente las esperanzas y los valores de esos duros, y a menudo satisfactorios, y otras veces tristes, tiempos que marcaron la intensificación de las luchas anti-imperialistas del Tercer Mundo en todo el orbe.[1] Él nunca ha perdido su furia—y durante la década de los ochentas existieron todas las razones para mantenerla—sino que a través de los años ha profundizado y ampliado sus productos. Ahora una revisión del trabajo de toda la vida de García está marcada más que con anticipación, con nostalgia. A mediados de la década de los ochentas, sus trabajos dípticos y trípticos en pastel abrieron toda una nueva serie de posibilidades de forma y contenido que deberían mantenerlo ocupado por mucho tiempo.

Esta anticipación necesariamente afecta la manera en cómo yo miro hacia atrás. La presente exposición se concentra en los grabados y afiches de García, la mayoría de los cuales fueron hechos entre 1967 y 1975, bajo la perspectiva de tantas esperanzadoras tormentas radicales. Pero estos grabados y afiches no pueden ser separados de los trabajos en pastel ni de las pinturas que han acompañado y complicado a muchas de las mismas imágenes durante los últimos quince años. En este genuino arte declarativo, el estilo y el contenido son interdependientes entre sí mismos. El trabajo múltiple es hecho encuadrado en el centro de contextos sociales, y es destilado para captar la atención, para llegar al corazón, ó para envolver a la conciencia. Este trabajo único y original en su estilo (como las recientes

Yet the direction has changed since 1968, when García learned to make silkscreen posters in the context of the Third World student strike at San Francisco State College, abandoning easel painting for a popular, political art. "Politics used to be my driving force. It isn't an overriding concern anymore," he told an interviewer in 1985. "Now it's what I think of the world, personalized. The technology of the picture has become important. Now many political works seem trying—embarrassing to one's eyes. It is very difficult to marry politics and technique, difficult to make it work. But I like to walk that fine line."[2]

A fine line is of course what the dispossessed, especially people of color who are bilingual, must walk in this country, where an anomaly called Official English is on the rise, accompanied by discriminatory immigration laws and pervasive promotion of the All-American Look. Even today, the historical emergence of Chicanismo within El Movimiento provides a point of departure for cultural organizing. As Tomás Ybarra-Frausto recalls, the sixties and early seventies were for Chicanos "a rare and intriguing period where artistic flowering was fused with a sense of historical inevitability, the consciousness that artists were assisting in the renewal and affirmation of a cultural legacy ravaged by suppression yet fecund enough to germinate a powerful renaissance." According to Gustave Segade, "We discovered universal meaning when we were most ourselves."[3] García participated in and continues to convey this simultaneously nurturant and aggressive drive.

Rupert García was born in French Camp, California, and grew up in Stockton, where his family worked in canneries, department stores, packing sheds, and in a meat plant. He went to Edison High School with Maxine Hong Kingston, graduating in 1959, the year he made an awkward but promising pastel portrait of James Dean and an oil painting of a white-faced clown; their faces fill the picture plane, predicting his "ideological portraits" of the next decade. Kingston has written that she sees in García's work their common background:

Yellow light hazes and gilds the San Joaquin Valley; the peat dirt blows from the fields into the city. We are from a part of town where people know the earth, how hard it is to make a living. We belong to families who keep their ethnic identities alive in America. We grew up before there were Chicanos and Asian-Americans and a Third World, and we know that voices that would call for revolution have to struggle against silence....So it took bravery for Rupert García to insist on producing Asian, Chicano, black faces— closeups so that the viewer has to consider the shapes and colors of eyes, noses, lips. To look at Rupert García's Vietnamese woman is to see—at last—myself, and to need to tear the gags from her mouth and to hear her voice.[4]

litografías) es evidencia adicional del respeto que el artista tiene por los temas e imágenes políticas que aborda. García sabe qué es lo que él sacrifica en aras de la claridad para el público en las versiones acabadas. Asi él se preocupa lo suficiente como para seguir profundizando en ello, interponiendo las imágenes de los afiches unas contra otras y unas con otras hasta echar a volar chispas diferentes y aún más sutiles.

Aún así, la dirección ha cambiado desde 1968, cuando García aprendió a hacer serigrafía en el contexto de la huelga de estudiantes tercermundistas en San Francisco State College, abandonando la pintura de caballete por un arte popular y político. "La política era mi fuerza inspiracional. Ella dejó de ser un interés descartable desde entonces," le dijo García a un periodista en 1985. "Ahora, ésto es lo que yo pienso del mundo, de manera personalizada. La tecnología de la pintura ha llegado a ser importante. Ahora muchos trabajos políticos parecen forzados—embarazosos para nuestros ojos. Es muy difícil combinar la política con la técnica, es difícil que trabaje. Pero a mí me gusta caminar en esa cuerda floja."[2]

Una cuerda floja es, claro está, la que los desposeídos, especialmente la gente bilingüe de color, tienen que caminar en este país en donde una anomalía llamada Inglés Oficial está en ascenso acompañada de leyes de inmigración discriminadoras y de una promoción omnipresente de la Autoimagen Idealizada promovida en los Estados Unidos de América. Aún ahora, la emergencia histórica del Chicanismo dentro del Movimiento provee un punto de partida para organizarse culturalmente. Como Tomás Ybarra-Frausto recuerda, la década de los sesentas y el principio de la de los setentas fueron para los chicanos "un período raro e intrigante cuando el florecimiento artístico se había fusionado a un sentido de inevitabilidad histórica, la conciencia de que los artistas estaban asistiendo a la renovación y afirmación de un legado cultural devastado por la supresión pero lo suficientemente fecundo como pra germinar en un poderoso renacimiento." Como Gustavo Segade lo planteó, "Nosotros descubrimos el significado universal cuando éramos más nosotros mismos."[3] García era un participante, y continúa siendo parte, en esta fuerza simultáneamente alimentadora y agresiva.

Rupert García nació en French Camp, California, y creció en Stockton, donde su familia trabajó en empresas enlatadoras de productos alimenticios, tiendas de departamentos, bodegas empacadoras, y en una planta de procesamiento de carne. Cursó sus estudios secundarios en Edison High School con Maxine Hong Kingston, graduándose en 1959, el año en que él hizo un burdo pero prometedor retrato a pastel de James Dean y un óleo de un payaso cariblanco; sus rostros llenan el plano pictórico, predicando sus

After high school, a stint in junior college, and a brief attempt to break into the San Francisco art world, García enlisted in the air force; as a member of the security services he was sent to a secret base (where they were passed off as Australians) in upcountry Thailand to guard the planes, napalm bombs, and other ordnances used to ravage Vietnam. ("Billowing, bubbling fire—damn, man," he recalled five years later. "When I became involved politically at San Francisco State in '68 I had to reconcile my involvement in Southeast Asia. It was tough to figure out."[5] On his return in 1966, García ended up studying art on the GI Bill at San

Rupert García, Indochina, 1965

Francisco State College and joined the antiwar movement with those in the Mexican American and other "minority" communities who had noticed that people of color provided a disproportionate amount of canon fodder in Vietnam. His commitment to the Third Worldanticolonial struggles that enlightened and emboldened people of color in the United States was augmented by El Movimiento and its three major issues: land rights (led by Reyes López Tijerina in northern New Mexico), civil rights (the Crusade for Justice, led by Corky Gonzáles in Denver), and La Causa—the *campesinos'*, or farmworkers', labor struggle (the United Farm Workers, led by César Chávez in California). In the arts García was inspired by El Teatro Campesino, which emerged from the UFW, and by Corky Gonzáles's stirring epic poem "I Am Joaquín," as well as by the Cuban revolution.

"retratos ideológicos" de la siguiente década. Kingston ha escrito que ella ve en el trabajo de García la formación común de ambos:

Una luz amarilla cubre y embellece el Valle de San Joaquín; el polvo sin tiempo sopla desde los campos hasta la ciudad. Nosotros somos de una parte del pueblo en donde la gente conoce la tierra, cuán difícil es ganarse la vida. Pertenecemos a familias que mantienen vivas sus identidades étnicas en los Estados Unidos. Crecimos antes de que hubieran chicanos y asiático-americanos y un Tercer Mundo, y sabemos que las voces que llaman a revolución tienen que luchar contra el silencio.... Así, tomó mucha valentía por parte de Rupert García producir rostros asiáticos, chicanos, negros—primeros planos realizados de tal manera que el observador tiene que considerar las formas y los colores de los ojos, narices, labios. Mirar a la mujer vietnamita en la obra de García es ver—al fín—a mí misma, y necesitar romper las mordazas de su boca y oír su voz.[4]

Al terminar la secundaria, un fugaz paso por la preparatoria, y un pequeño intento de entrar al mundo del arte en San Francisco, García se enlistó en la fuerza aérea; como miembro de los Servicios de Seguridad, fue mandado a una base secreta (donde usaban sombreros de campaña para parecer australianos) en el interior de Tailandia a cuidar los aviones, las bombas de napalm, y otros pertrechos usados para desolar al Viet Nam. "Fuego masivo y apocalíptico—qué maldición, hombre," recuerda García años después. "Cuando me envolví en política en San Francisco State en el año sesenta y ocho, tuve que reconciliar mi participación en el sudeste de Asia. Fue difícil de resolver."[5] A su regreso en 1966, García terminó estudiando arte con ayuda del fondo económico estudiantil para veteranos de las fuerzas armadas en San Francisco State College. Entonces se unió al movimiento pacifista con aquellos en las comunidades mexicano-americanas y otras comunidades de "minorías" que se habían dado cuenta que la gente de color proveyó una cantidad desproporcionada de carne de cañón en Viet Nam. Su compromiso con las luchas anticolonialistas del Tercer Mundo que guiaron e impulsaron a la gente de color en los Estados Unidos fue aumentado por el Movimiento y sus tres planteamientos principales: Derechos de Propiedad sobre la Tierra (dirigido por Reyes López Tijerina en el norte de Nuevo México), derechos civiles (la Cruzada por la Justicia dirigida por Corky González en Denver), y La Causa—la lucha laboral de los campesinos (la UFW dirigida por César Chávez en California). En las artes, García se inspiró en El Teatro Campesino, el cual emergió de la UFW, y en el incitante poema épico de Corky González, "Yo Soy Joaquín," así como en la revolución cubana.

El catalizador inmediato para García fue la huelga

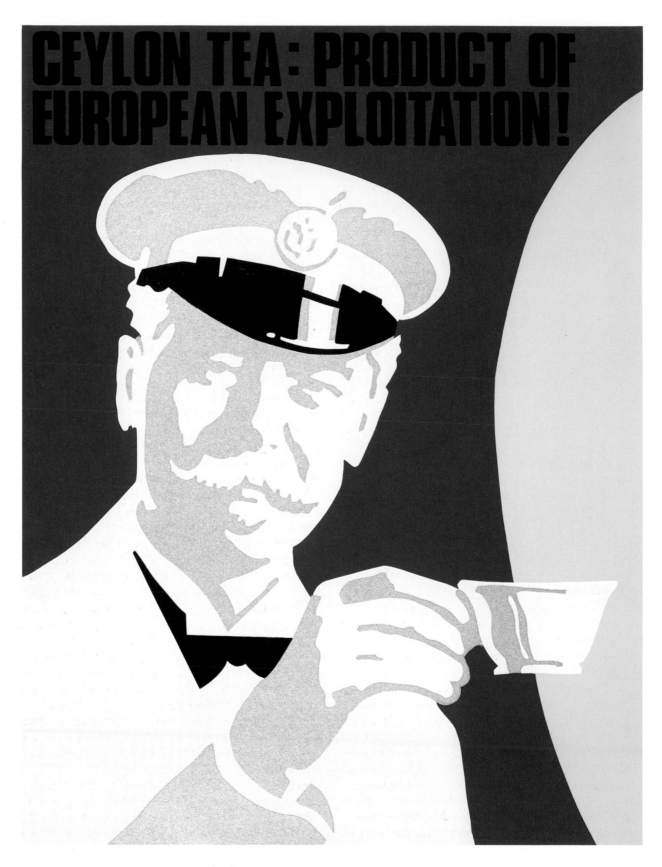

Ceylon Tea: Product of European Exploitation!

1972 (cat. no. 38)

The immediate catalyst for García was the student strike at San Francisco State, which "marked the first time that Mexican American and other Third World student activists united to create a politically explosive 'rainbow' coalition," which fit right into García's emergent internationalism.[6] He participated in a poster-making workshop set up by the strikers, and "learned to work in a collective—critiquing, sharing, subduing one's ego."[7] For the next seven years, his favored medium was the brilliant flat colors of silkscreen.

While in college, especially under the tutelage of social photographer John Guttman, who introduced him to progressive artists in Europe such as Renato Guttuso and Juan Genovés, García also learned from Pop Art, especially from Jim Rosenquist's lyrical giantism, Robert Indiana's colors-as-form, and the hybrid figuration of R. B. Kitaj. But the most individual and exciting element of his early prints and posters is their relationship to action, and to activism. (Another major influence was Emory Douglas, minister of culture for the Black Panthers.) Returning from Southeast Asia at the height of the antiwar movement, García must have been struck, and angered, by the contradictions between what he had witnessed there and the images of the Vietnam war being passed off on the North American public. A closer look at how "Hispanics" were represented in the media and repulsion for the reified world created by advertising was combined with a gradual radicalization that culminated in the student strike and his direct involvement through art.

The sixties were also the period in which media analysis took hold of the Left's imagination, where it still reigns. In 1969 García illustrated Todd Gitlin's article, "14 Notes on Television and the Movement," in the New Left tabloid *Leviathan*. He looked at the ways Americans receive information and how it affects them. In 1970 he received a master's degree in printmaking, having done substantial research in art history and theory. He submitted a thesis entitled "Media Supplement," which deconstructed Pop Art and exposed its entanglement with the status quo it supposedly criticized. Since his earliest sketches, when as a teenager in the fifties he copied from his mother's movie magazines, cartoons, comics, and television, García has had an ambivalent relationship to the mass media. He realized early on that despite their fascination with the consumer's fantasy worlds, his own people were rarely included therein except as stereotypes used to encourage the consumption not only of goods, but of cultures. By wrenching the media's products and sensibility around to his own way of thinking, he felt he had won a battle against false witnesses. "My art," he wrote,

is committed to the paradox that in using mass-media I am using a source which I despise and with which I am at war.

estudiantil en San Francisco State College, el cual "marcó la primera vez que activistas estudiantiles mexicano-americanos y de otros países del Tercer Mundo se unieron para crear una políticamente explosiva coalición "arcoíris," que vino a satisfacer plena y cabalmente el emergente internacionalismo de García.[6] García participó en un taller de fabricación de afiches organizado por los estudiantes huelgistas, y "aprendió a trabajar en un colectivo—criticando, compartiendo, subyugando nuestros egos."[7] Durante los siguientes siete años, los brillantes colores de los trabajos en serigrafía serían su medio favorito.

Mientras estaba en la universidad, especialmente bajo la tutela del fotógrafo social John Guttman, quien lo introdujo a artistas progresistas europeos, tales como Renato Guttuso y Juan Genovés, García también aprendió del Arte Pop, especialmente del gigantismo lírico de Jim Rosenquist, de los colores-como-forma de Robert Indiana, y de la figuración híbrida de R. B. Kitaj. Pero el elemento más excitante e individual de sus primeras impresiones y afiches es su relación con la acción, con el activismo. (Otra influencia importante fue Emory Douglas, Ministro de Cultura de los Panteras Negras.) A su regreso del sudeste de Asia durante el apogeo del movimiento pacifista en contra de la guerra en el Viet Nam, García debe haber sido golpeado, e indignado, por las contradicciones entre lo que él había presenciado allí y las imágenes de la guerra del Viet Nam que estaban siendo presentadas al público estadounidense. Una mirada más cercana a cómo los "hispanos" estaban representados en los medios masivos de comunicación, y una repulsión hacia la falsa materialización del mundo creada por los medios publicitarios fue combinada por una gradual radicalización que culminó con la huelga estudiantil y la participación directa a través de su arte.

La década de los sesentas fue también el período en el cual los análisis sobre la comunicación masiva se asentaron en la imaginación de la Izquierda, en donde todavía reina. En 1960, García ilustró el artículo de Todd Gitlin, "14 Notas sobre la Televisión y el Movimiento" en el tabloide de la Nueva Izquierda, *Leviathan*. García estudió las formas en cómo los estadounidenses reciben la información, y cómo ésto los afecta. En 1970, García se recibió con un postgrado en impresión gráfica, habiendo conducido una cantidad grande de investigaciones en la historia de arte y teoría. Él submitió una tesis llamada "Suplemento del Medio Artístico," en la que desconstruía el Arte Pop y exponía su enmarañamiento y conexiones directas con el status quo que supuestamente éste critica. Desde sus primeros bosquejos, cuando él era un adolescente en la década de los cincuentas y copiaba de las revistas faranduleras de su madre, de las caricaturas animadas e impresas, y de la televisión, García ha tenido una relación ambivalente hacia los medios de comunicación masiva. Se dió cuenta

In using the images of mass-media I am taking an art form whose motives are debased, exploitative, and indifferent to human welfare, and setting it into a totally new moral context. I am, so to speak, reversing the process by which mass-media betray the masses, and betraying the images of mass-media to moral purposes for which they are designed; the art of social protest.[8]

García's posters and prints can be seen as a rebellious response to the way immigrants arriving in America are deluged with advertisements for the paraphernalia of acculturation:

Chicano consumers were inundated with massive advertising campaigns through all the mass media praising products and validating a way of life manifestly at odds with the subsistence wage levels and cultural aspirations of the community. Anguished by the lack of social mobility, frustrated by insensitive institutions which fostered discrimination and racism, and exploited in economic terms, the Chicano community engaged in a total evaluation of its relationship to the dominant society.[9]

Or, as it was phrased in the core Chicano manifesto of the period, El Plan Espiritual de Aztlán of 1969, "Our cultural values of life, family and home will serve as a powerful weapon to defeat the gringo dollar value system and encourage the process of love and brotherhood."[10] This manifesto as a whole was important to García and others because of its emphasis on the reidentification of Mexican American mestizos with their indigenous roots, which led to Chicano solidarity with the burgeoning American Indian Movement, the occupation of Alcatraz, and any number of intangible reclamations of a powerful past. Faces, figures, and symbols from the history of the Native Americas appear in a number of García's most moving images, such as *Perromictlan* (p. 19, cat. no. 42), *Festival del Sexto Sol* (p. 20, cat. no. 48), and *Poetry Benefit for the Longest Walk* (p. 21, cat. no. 73).

Around this time García began his "photo morgue"—the mass media's involuntary contributions to his adversarial practice. Understanding from his study of Pop Art that appropriation alone simply implicated the appropriator in the sins of his sources, García not only flaunted his cooptation of the media by using their ingredients for his recipe, but simultaneously practiced the "cultural reclamation" that remains a major element in Chicano cultural politics. Unlike the postmodernists who blandly swallow readymade photographic imagery whole, or the sixties' fine artists like Larry Rivers or Roy Lichtenstein who made "art about art," he transformed the usually black-and-white pictures into luscious color that proudly proclaimed if not the hand then the spirit of the artist.

temprano de que a pesar de su fascinación con los mundos fantásticos de los consumidores, su propia gente era rara vez incluída en esos mundos fantásticos excepto como estereotipos usados para promover el consumo no sólo de bienes y productos, sino también de culturas. A través de retorcer los productos de los medios masivos de comunicación y la sensibilidad alrededor de su propia manera de pensar, García sintió que había ganado la batalla contra el testigo falso. "Mi arte," escribió,

está dedicado a la paradoja consistente en que al usar los medios masivos de comunicación, yo estoy usando un recurso que desprecio y con el cual estoy en guerra. Al usar las imágenes de los medios masivos de comunicación social estoy tomando una forma artística cuyos motivos son denigrantes, explotativos, e indiferentes al bienestar humano y poniéndola dentro de un contexto moral totalmente nuevo. Yo estoy, por así decirlo, revirtiendo el proceso por el cual la comunicación masiva traiciona a las masas, y reduciendo las imágenes de la comunicación masiva a propósitos morales para los cuales no han sido diseñadas; el arte de la protesta social.[8]

Los posters y los grabados de García pueden ser vistos como una respuesta de rebeldía a la manera en cómo los inmigrantes que llegan a los Estados Unidos son engañados con anuncios publicitarios promoviendo los elementos y atavíos necesarios para la aculturación:

Los consumidores chicanos fueron inundados con campañas masivas de publicidad a través de los medios sociales de comunicación alabando productos y convalidando una forma de vida manifiestamente contraria a los niveles salariales de subsistencia y a las aspiraciones culturales de la comunidad. Angustiada por la falta de movilidad social, frustrada por las insensibles instituciones que apadrinan la discriminación y el racismo, y explotada en términos económicos, la comunidad chicana emprendió una evaluación total de su relación con la sociedad dominante.[9]

O, como fue enunciado en el manifiesto fundamental chicano de la época, El Plan Espiritual de Aztlán de 1969: "Nuestros valores culturales sobre la vida, la familia y el hogar servirán como un arma poderosa para derrotar el sistema de valores sociales del dólar gringo y para promover el proceso de amor y fraternidad."[10] Este manifiesto en su total fue muy importante para García y para otros por su énfasis en el redescubrimiento e identificación de los mestizos mexico-americanos con sus raíces indígenas, lo cual llevó a la solidaridad chicana con el rápidamente creciente Movimiento Indigena-Americano, la ocupación de la isla de Alcatraz, y cualquier número de reclamos intangibles de un poderoso pasado. Rostros, figuras, y símbolos de la historia de los Indigenas-Americanos (o "Nuestra America," como lo

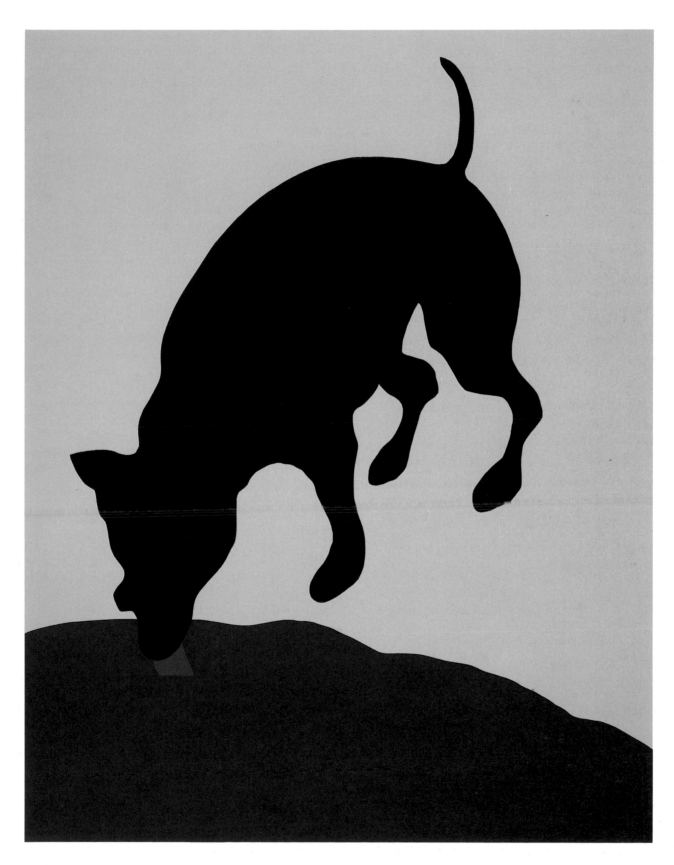

Perromictlan, 1973 (cat. no. 42)

García was also aware that these pictures would not be welcomed with open arms by the "official bourgeois culture," which was unsympathetic to the kind of images that make it possible to live in a "very oppressive, inhuman, and degrading social fabric." He saw mainstream resistance to Latino expressions as "directed ultimately at our existence—for a people have never existed without an art which is identifiable to them."

For all the sixties' rebellious cultural separatisms, they were the seedbed for the recently renewed project of a "hybrid" or "syncretic" culture for the twenty-first

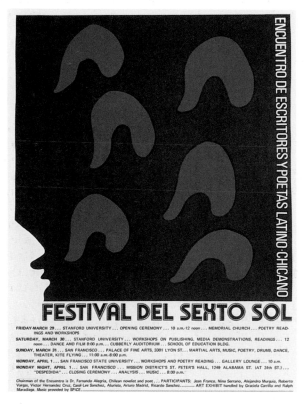

Festival del Sexto Sol, 1974 (cat. no. 48)

century, for a post-Columbian world—a not-so-rosy review of five hundred years of a Columbian world that will take place in 1992 (a commemoration that García intends to take on as part of his longterm project of resisting and revising the Melting Pot). More than any other people of color in the United States, with their mixture of indigenous, European, and sometimes African and Asian descent and their long history in this nation's West, Chicanos have been explorers of a cultural *mestizaje* that will characterize the next century, the "border culture" Guillermo Gómez-Peña reveals with such eloquence in his writings and performances. As Cuban art critic Gerardo Mosquera has remarked, our future can be changed by "activating the Third World's values" so that Africans, Asians, and Latin

planteó José Martí) aparecen en varias de las imágenes más conmovedoras de García, como *Perromictlan* (p. 19, cat. no. 42), *Festival del Sexto Sol* (p. 20, cat. no. 48), y *Beneficio de Poesía para la Marcha Más Larga* (Poetry Benefit for the Longest Walk) (p. 21, cat. no. 73).

Alrededor de este período, García comenzó su "foto morgue"—las contribuciones involuntarias de los medios de comunicación masiva a su práctica adversarial. Entendiendo de su estudio sobre el Arte Pop que la sola apropiación simplemente implicaba al apropiador en los pecados de sus fuentes artísticas, García no sólo alardeaba de su aprovechamiento de los medias artísticos al usar sus ingredientes en su receta, sino que simultáneamente practicó la "reclamación cultural" que se mantiene como un elemento principal en la política cultural chicana. A diferencia de los postmodernistas que suavemente se tragan totalidades de imágenes mentales fotográficas prefabricadas, o los finos artistas de los años sesentas, como Larry Rivers o Roy Lichtenstein quienes hicieron "arte sobre arte," García transformó las pinturas, usualmente en blanco y negro, en deliciosos colores que proclamaban orgullosamente si no la mano, el espíritu del artista.

García sabía que estas pinturas no serían recibidas con los brazos abiertos por "la cultura oficial burguesa," la cual no veía con buenos ojos la clase de imágenes que hacen posible vivir en "una estructura social muy opresiva, inhumana, y degradante." El vió esa resistencia predominante a las expresiones latinas como "dirigida en última instancia a nuestra existencia—porque un pueblo nunca ha existido sin un arte que es identificable para ellos."

Todos los separatismos culturales rebeldes que marcaron los años sesentas, se convirtieron en la materia germinal del recientemente renovado proyecto de una cultura "híbrida" o "sincrética" para el siglo XXI, por un mundo postcolombino, empezando por el final—una re-visión no muy prometedora de quinientos años de un mundo colombino que se va a llevar a cabo en 1992 (una conmemoración que García intenta desarrollar como parte de su proyecto a largo plazo de resistir y revisar la teoría del crisol o la mezcla de las culturas). Más que ningún otro pueblo de color en los Estados Unidos, los chicanos, con su mezcla racial indígena, europea (y a veces africana o asiática) y su larga historia en el Oeste de esta nación, han sido los exploradores de un mestizaje cultural que caracterizará al próximo siglo, la "cultura fronteriza" que Guillermo Gómez-Peña revela con tanta elocuencia en su obra escrita y en sus actuaciones. Como ha dicho el crítico cubano de arte, Gerardo Mosquera, nuestro futuro puede ser cambiado "activando los valores del Tercer Mundo" de tal manera que los africanos, los asiáticos, y los latinoamericanos "creen cultura occidental, asi como los barbaros crearon el cristianismo."[11]

Americans "make occidental culture, just as the 'barbarians' made Christianity."[11]

Some Chicanos in the Southwest still live on or near their ancestral homes, though most of the original land grants were stolen from them after 1848. Others look through a transparent border to and from Mexico— *el otro lado* from both sides now. In many Mexican American families, the generations are more closely related and grandparents better respected than usual, providing a smoother bridge to history than is found in the dominant culture with its media-induced social amnesia. Family, history, memory, language, locally

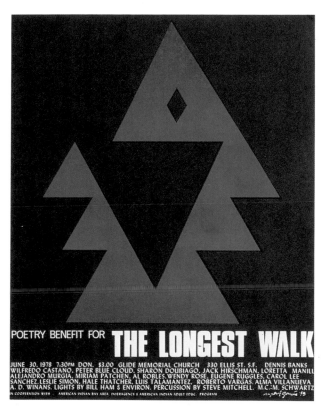

Poetry Benefit for the Longest Walk,

1978 (cat. no. 73)

evolved syncretic religions, and reborn politics fueled by racism and the constant flow of new immigrants from the South have endowed Mexican Americans with a multifaceted culture, ranging from rural tradition to *cholo-punk*, which is reflected in the contemporary popular arts of posters and t-shirts.

Chicano poster art has a rich history. Along with the classic Mexican murals, the more modest "commercial" murals on the walls of *pulquerías*, and the contemporary *placas* (a specifically Chicano style of graffiti), there are the Mexican revolutionary broadsides and posters, José Guadalupe Posada's popular commentaries, 1930s posters from the United States, Latin America, and Spain, such as those by the Mexican Taller

Algunos chicanos en el suroeste aún viven en o cerca de sus hogares ancestrales, a pesar de que la mayoria de las concesiones originales de titulos sobre las tierras les fueron robadas después de 184. Otros miran a través de una frontera transparente hacia y desde México—*el otro lado* es desde ambos lados ahora. En muchas familias méxico-americanas, las generaciones están más estrechamente relacionadas y los abuelos son más respetados que lo usual, proveyendo un puente histórico más transitable que el existente en la cultura dominante con su amnesia social inducida por los medios masivos de comunicación. La familia, la historia, la memoria, el lenguaje, las religiones sincréticas desarrolladas localmente, y las políticas renacientes vitalizadas por el racismo y el flujo constante de nuevos inmigrantes provenientes del sur han dotado a los méxico-americanos de una cultura multifacética, que va desde la tradicion rural hasta el *cholo-punk*, que se refleja en el arte popular contemporáneo de los afiches y camisetas de punto.

El arte chicano del afiche tiene una rica historia. A la par de los murales clásicos mexicanos, los más modestos murales "comerciales" en las paredes de las pulquerías, y las contemporáneas *placas* (un estilo de grafito específicamente chicano), están los panfletos y posters de la revolución mexicana, los comentarios populares de José Guadalupe Posada, los afiches de los años treintas en los Estados Unidos, Latino América y España, así como los del Taller Mexicano de Gráfica Popular, y afiches de la rebelión estudiantil mexicana de 1968 de antes y después de la masacre de Tlatelolco. Otro modelo contemporáneo influyente es la producción de los artistas gráficos cubanos que trabajan colectivamente en OSPAAL (Organización en Solidaridad con los Pueblos de Africa, Asia, y Latinoamérica) desde principios de los años sesenta. Los cubanos han desarrollado un estilo que balancea la militancia, un innovativo sistema de imágenes, y un diseño decorativo. Estos afiches hechos para promoción comercial de películas y para causas politicas internacionales comenzaron a ser visibles en los Estados Unidos alrededor del año de 1970, y los de René Mederos fueron exhibidos el mismo año en la recién fundada Galería de la Raza en San Francisco, en donde García fué muy impresionado por ellos.

Los artistas chicanos especializados en afiches documentan la historia del arte y la responsabilidad social colectiva en relación con la familia extendida y con la comunidad de una manera culturalmente democratica que no es muy familiar a muchos artistas urbanos alienados. Por ejemplo, los afiches creados por el Centro de Serigrafía de La Raza, fundado en San Francisco en 1971, constituyeron "un revelador libro de historia pictórica sobre la vida de la comunidad urbana de habla hispana del barrio de la misión" en San Francisco. "Las ventanas y las paredes de las pequeñas

21

de Gráfica Popular, and posters from the 1968 Mexican student rebellion before and after the Tlatelolco massacre. Another influential contemporary model is the production of Cuban graphic artists working collaboratively in OSPAAL (Organization of Solidarity of the Peoples of Africa, Asia, and Latin America) since the early sixties. They have developed a style that balances militancy, innovative imagery, and decorative design. These posters for films and international causes began to be visible in the United States around 1970, and those of René Mederos were shown the same year at the new Galería de la Raza in San Francisco, where García, a co-founder, was much impressed by them.

Chicano poster artists document the history of art and collective social responsibility in relation to extended family and community in a culturally democratic way that is unfamiliar to many alienated urban artists. For instance, the posters made in La Raza Silkscreen Center, founded in San Francisco in 1971, constituted "a revealing pictorial history book of the life of the urban Spanish-speaking Mission community" in San Francisco. "The windows and walls of small stores and businesses, from butcher shops to clothing stores, provide public space for a truly popular gallery."[12] Works thus sheltered by the community are made in a different context from the atmosphere in which most urban posters pass their brief street lives. At their best, Chicano posters enter (or are welcome into) communal history rather than reacting one-sidedly in opposition to the dominant culture. There has been some debate about whether certain posters are "commercial" while others are "art," but why bother to separate them when they are all part of life? "For me," says García, "the most important question is how I visually express this social dynamic between me and the rest of the viewing world. The poster and the event announced are both part of the event."

In the sixties and early seventies, the Mexican American languages of the streets—caló, pocho—as well as references to Maya and Nahua (Aztec) culture were (and still are) evolving into the mainstream. They found their way from the corridos into literature, in the same way that their contemporary image counterparts in graffiti, tattoo, makeup, calendars, yard shrines, fashion, and pure style (personal and automotive) have found their way from broadsides, retablos, and calendars into contemporary Chicano art.

García has cited characteristics of Chicano poster art: the use of a polyglot of languages and of images such as the calavera, the corazón, jalapeños, nopales, the rose, the Pachuco, the farmworker, the low-riders, pintos-pintas, and the Virgen de Guadalupe. Although García uses these prototypical Chicano images sparingly in his posters and prints, their appearance is usually reinvested with an energy they have sometimes lost through constant and not always skillful repetition.

tiendas y negocios, desde las ventas de carne hasta las ventas de ropa, proveen el espacio público para una verdadera galería popular."[12] Los trabajos así protegidos por la comunidad están hechos en un contexto diferente a la atmósfera en la cual la mayoría de los afiches urbanos pasan a su cortísima vida en las calles. En su máxima expresión, los afiches chicanos entran (o son bienvenidos) en la historia comuncal en lugar de reaccionar unilateralmente en oposición a la cultura dominante. Ha habido algun debate sobre si ciertos afiches son "comerciales" mientras otros son "arte," pero, ¿porqué molestarnos en separarlos, si ambos son parte de la vida? "Para mí," dice García, "la pregunta importante es ¿cómo puedo yo expresar visualmente esta dinámica social que ocurre entre mí y el resto del mundo vidente...? El afiche y el evento anunciado son ambos parte de ese evento."

En los años sesenta y a principios de los setentas, los lenguajes callejeros méxico-americanos—caló, pocho—así como las referencias a las culturas maya y nahua (azteca) estaban (y todavía lo están) evolucionando alrededor de la cultura dominante. Estos lenguajes populares encontraron la forma de pasar de los corridos a la literatura, así como sus contrapartes contemporáneas en imágenes como el grafito, los tatuajes, el maquillaje, los calendarios, los altares caseros, la moda, y el puro estilo (personal y automotivado) han pasado de los panfletos, los retablos y los calendarios al arte chicano contemporáneo.

García ha citado varias características del arte chicano del afiche: el uso políglota de lenguajes y de imágenes tales como la calavera, el corazón, los jalapeños, los nopales, la rosa, el pachuco, el labrador, los low riders, los pintos-pintas, o la virgen de Guadalupe. Aunque García usa esas imágenes prototípicas chicanas frugalmente en sus afiches y grabados, su apariencia es usualmente re-vestida con una energía que perdieron alguna vez a través de una constante y no siempre habilidosa repetición. Él a menudo usa el arte folklórico en sus trabajos al pastel (y en los tres afiches de The Mexican Museum con un toro policromático (p. 24, cat. no. 91), el corazón llameante—milagro [p. 25, cat. no. 76], y el gallo (el gallo cantador, el símbolo de la hombría [p. 25, cat. no. 58]). García es especialmente aficionado a las máscaras (cat. no. 91), a las cuales ve como "un símbolo de la resistencia de la cultura popular y de la vitalidad básica de la vida," el poder de la imaginación y de la fantasía, "la habilidad del espíritu humano para sobrevivir en condiciones adversas." Su amor por las artes vernaculares es heredado: una de sus abuelas hacía muñecas y animales de papel, la otra hacia trajes para un ballet folklorico; una tía abuela en México creaba esculturas policromáticas; su madre dibujaba y tenía esperanzas de llegar a ser una gran artista, y otros miembros de su familia cantaban, danzaban, y estudiaban música y teatro.

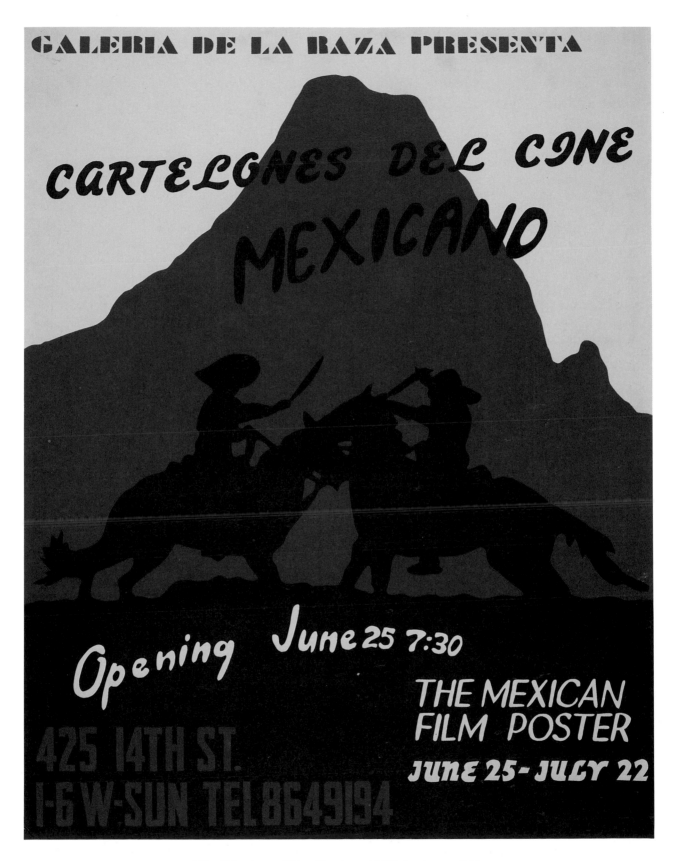

The Mexican Film Poster, 1971 (cat. no. 33)

The Mexican Museum, 1985 (cat. no. 91)

He often uses folk art in his pastels (and in three Mexican Museum posters that depict a multicolored bull [p. 24, cat. no. 91], the flaming heart *milagro* [p. 25, cat. no. 76], and *el gallo*, the crowing cock, which is the symbol of manhood [p. 25, cat. no. 58]). He is especially fond of masks (cat. no. 91), seeing them as a "symbol of popular culture and life's basic vitality," the power of imagination and fantasy, and "the human spirit's ability to survive adverse conditions." García's love of vernacular arts is inherited: one of his *abuelas* made dolls and animals of tissue paper, another made costumes for a ballet *folklórico*; a great-aunt in Mexico created poly-

García tambien cita como chicano "un sentido único del color." "Con esto," dice, "yo no quiero decir que estamos biológicamente determinados para usar los colores brillantes e intensos, o los colores visualmente provocativos que a menudo son identificados con el pueblo o el arte popular de México, sino que general y culturalmente hablando, los chicanos y mexicanos han tenido la tendencia de usar los colores cálidos e intensos y tonalidades de arcilla no sólo en el arte sino que también en las esferas de la vida real."[13]

Muy temprano en su trabajo, García desarrolló su original characterística personal para los afiches—el

The Mexican Museum, 1978 (cat. no. 76)

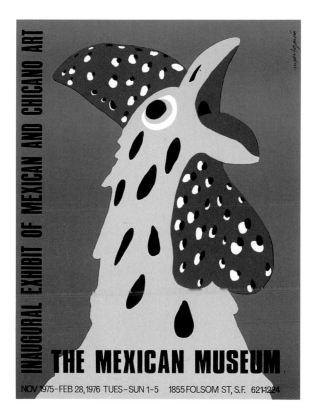

The Mexican Museum Inaugural Exhibit of

Mexican and Chicano Art, 1976 (cat. no. 58)

chrome sculptures; García's mother drew and had hoped to be an artist, and other family members sang, danced, and studied music and theater.

García also cites as Chicano "a unique sense of color." "By this," he says, "I do not mean we are biologically determined to use bright warm colors or the visually provoking colors often identified with the folk or popular arts of Mexico, but that generally and culturally speaking Chicanos and Mexicans have tended to use hot colors and earth tones not only in art but in spheres of everyday life as well."[13]

Early on García developed his poster trademark— the face seen so close up that its outer perimeter has vanished. From their walls (of streets or galleries), Angela Davis (p. 2, cat. nos. 30a–d), David Alfaro Siqueiros (cat. nos. 49a–c), Pablo Picasso (cat. nos. 46a– b), Frida Kahlo (p. 6, cat. no. 57; cat. nos. 75a–b; cover,

rostro visto tan de cerca que sus contornos externos desaparecen. Desde sus paredes (en calles o galerías), Angela Davis (p. 2, cat. nos. 30a–d), David Alfaro Siqueiros (cat. nos. 49a–c), Pablo Picasso (cat. nos. 46a– b), Frida Kahlo (p. 6, cat. nos. 57; cat. no. 75a–b; cubierta, cat. no. 103), Emiliano Zapata (p. 1, cat. no. 7), Nelson Mandela (p. 27, cat. no. 83), Inez García, Pancho Aguila (p. 26, cat. no. 70), George Orwell, un personaje maya muy seriamente dignificado (cat. nos. 19a–b), una mujer vietnamita gritando (p. 39, cat. no. 23), Pedro Albizú Campos (cat. nos. 51a–b), la madre Jones (cat. nos. 97–98), y muchos otros, nos confrontan, demandando nuestra atención. Cuando la han conseguido, ellos nos transmiten un mensaje que comparten con el artista, y esta combinación de voces no puede ser ignorada.

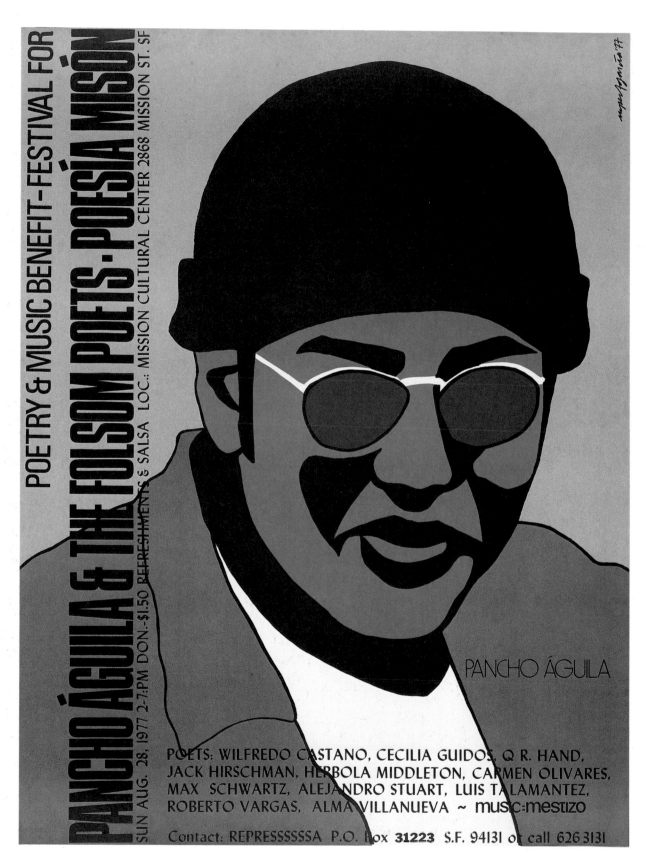

Pancho Aguila & the Folsom Prison Poets—

Poesía Mis[i]ón, 1977 (cat. no. 70)

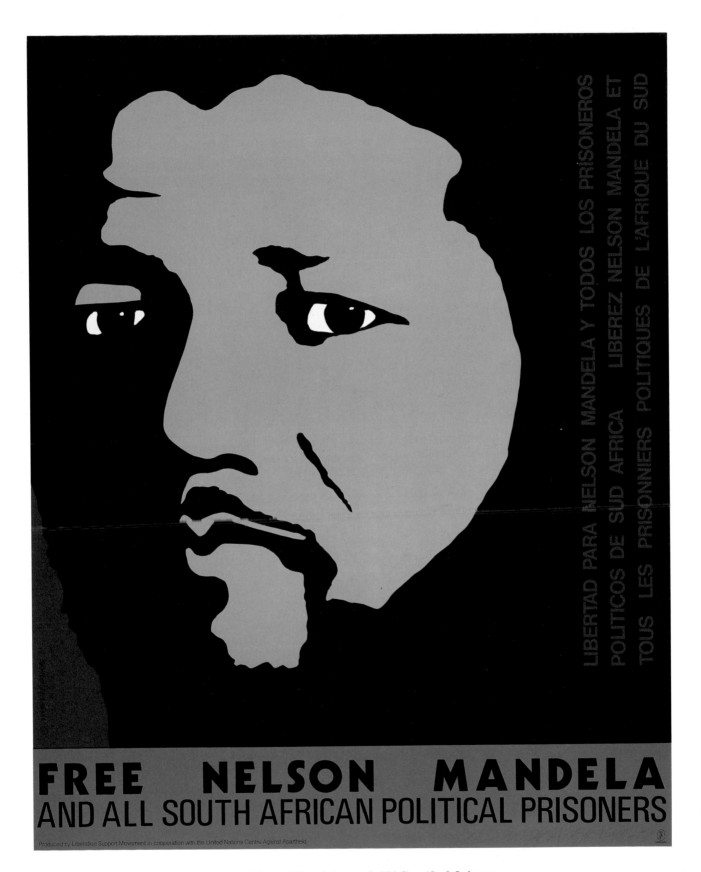

Free Nelson Mandela and All South African

Political Prisoners, 1981 (cat. no. 83)

cat. no. 103), Emilio Zapata (p. 1, cat. no. 7), Nelson Mandela (p. 27, cat. no. 83), Inez García, Pancho Aguila (p. 26, cat. no. 70), George Orwell, a sternly dignified Maya (cat. nos. 19a–b), a screaming Vietnamese woman (p. 39, cat. no. 23), Pedro Albizú Campos (cat. nos. 51a–b), Mother Jones (cat. nos. 97–98), and many others confront us, demanding attention. Once they have it, they convey a message shared by the artist, and their combined voices cannot be ignored.

García's posters and prints are not merely "mediated"—the product of a once-removed experience of the world. They are informed by his own life, which is in turn journalized, or re-visualized, emerging in a series of ferociously cropped and dramatic closeups that have been called the "ideological portraits." These are images intended to bring injustice and radical change to life, to bring the faces of history's Third World protagonists up on the screens of the dominant culture. As the Poetasumanos collective wrote in *El Tecolote*,

when one enters Rupert García's *Portraits/Retratos* exhibit, one immediately becomes engaged within the inner struggles of a group of faces which persuade, almost insist the viewer participate. It is like the heaviness one experiences living under the walls of a room full of the solemn portraits of one's ancestors … all vaguely discernible along the borders of memory closest to one's immediate experience. … How very distant they are from the space one inhabits, yet how dependent one is upon their existence. … It is as if one is no longer confined within the safe limitations which provide a secure surface from which to operate everyday life. … Each piece becomes a fuse that ignites a vast series of recollections and associations between images and historical moments.[14]

Having learned about scale from large-screen movies and from *los tres grandes*—the great Mexican muralists Rivera, Siqueiros, and Orozco (as well as from Jean Charlot, whom he knew personally)—García adapted it to much smaller sizes, maintaining the massive qualities of his models. Although the style of all García's portraits is similar, his use of color and composition brings to each a specific mood—militant, melancholy, majestic. Despite their boldly simplified graphics and flat fields of brilliant color, they are rarely rhetorical caricatures, even when he utilizes sixties poster clichés—photo images reduced to stark contrasts and/or the psychedelically vibrating colored equivalents. From the beginning, García recast these conventions by accentuating the formal eccentricity of the photoshadows—black patches and lines—almost autonomous shapes, as in the 1967 etchings *The War and Children* (cat. no. 2) and *Black Man with Glasses* (cat. nos. 4a–b), or in Siqueiros's visionary gaze, profiled so the black curves of shadows shelter and embrace his features (cat. nos. 49a–c). At their best, the "ideological portraits" are icons, even monuments, to the accomplishments, and

Los afiches y grabados de García no estan simplemente "entrepuestos"—productos de una experiencia ya desaparecida de este mundo. Estos afiches y grabados son informados por la propia vida de García, la cual es a su vez reportada, o re-visualizada, emergiendo en una serie de dramáticos y ferozmente recortados ampliaciones de imágenes que han sido llamados "retratos ideológicos." Éstas son imágenes que intentan trer a la vida la injusticia y el cambio radical, traer a las pantallas de la cultura dominante los rostros de los protagonistas de la historia del Tercer Mundo. Como el colectivo Poetasumanos escribío en el periodico *El Tecolote*:

cuando uno entra a la exhibición *Portraits/Retratos* de Rupert Garcia, uno inmediatamente se encuentra envuelto en las luchas internas de un grupo de rostros que persuaden, casi insisten en que el espectador participe. Es como la pesadez que uno experiencia cuando vive bajo las paredes de un cuarto lleno de retratos solemnes de nuestros antecesores … todo es vagamente discernible de acuerdo a los límites de nuestra memoria que están más cerca a nuestra experiencia inmediata … Cuán lejanos están del espacio en que uno habita, pero cuán dependiente es uno de su existencia. … Es como que si uno ya no está nunca más confinado dentro de las protectoras limitaciones que proveen una superficie segura desde la cual manipulamos la vida diaria. … Cada parte llega a ser un fusible que desencadena una vasta serie de recuerdos y asociaciones entre las imágenes y los momentos históricos.[14]

Habiendo aprendido sobre escalas en la pantalla grande de las películas y de *los tres grandes*—los grandes muralistas mexicanos, Rivera, Siqueiros, y Orozco (así como de Jean Charlot, a quien conoció personalmente)—García adaptó esas escalas a tamaños mucho más reducidos, manteniendo la masiva calidad de sus modelos. Aún cuando el estilo de todos los retratos de García es similar, su uso del color y la composición le da a cada uno un estado de ánimo específico—militante, melancólico, majestuoso. A pesar de sus audazmente simplificados gráficos y perspectivas planas de color brillante, éstos retratos son rara vez caricaturas retóricas, aún cuando él utiliza elementos estereotipados de los afiches de la década de los sesenta—imágenes fotográficas reducidas a rígidos contrastes y/o sus equivalentes de colores que vibran psicódélicamente. Desde el principio, García redefine estos convencionalismos por medio del acentuamiento del excentricismo formal de las sombras fotográficas—áreas negras y líneas—formas casi autónomas, como en los grabados en metal de 1967 llamados *La Guerra y los Niños* (The War and Children) (cat. no. 2) y *Hombre Negro con Anteojos* (Black Man with Glasses) (cat. nos. 4a–b), o en la visionaria mirada fija de Siqueiros, delineada de tal manera que las negras curvas de las sombras acogen y abrazan sus rasgos (cat. nos. 49a–c).

Cambios, 1972 (cat. no. 37)

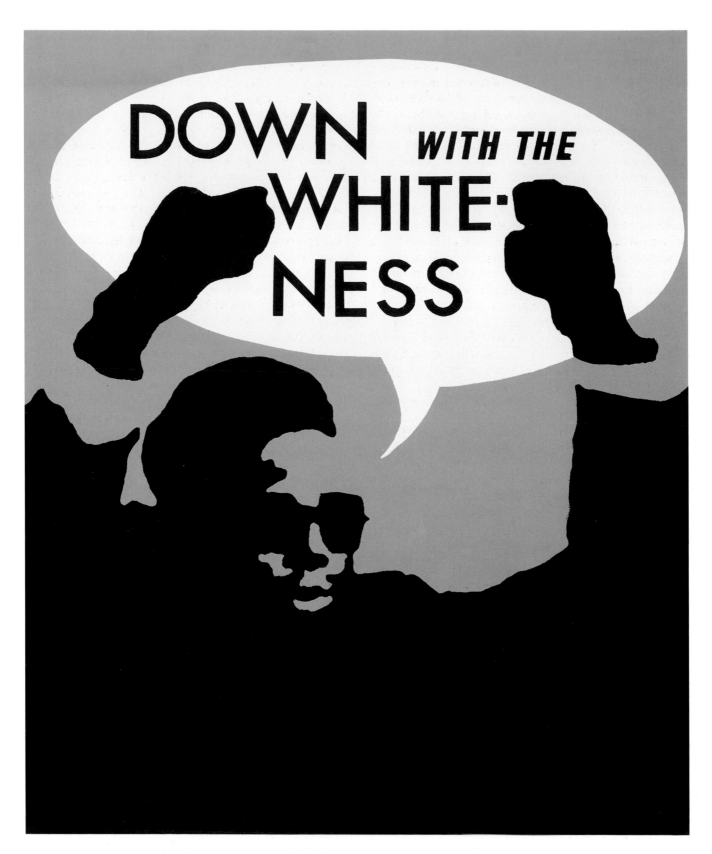

Down with the Whiteness, 1969 (cat. no. 10)

sometimes sufferings, of those portrayed, as well as visual homages to their intellectual or social courage. Stylistically there are similarities to Alex Katz's magnified portraits, but the intensity of García's heroes contrasts with the rather bland intimacy of Katz's friends. Here facial features accrue meaning from their subject's lives, with which we are familiar because they are public figures. Sometimes García has reinvested his artist subjects (Goya, Courbet [p. 40, cat. no. 100], van Gogh, Manet [p. 41, cat. no. 101]) with the passionate political beliefs deprived them by a neutralized history. (In the United States Picasso is hardly packaged as a "political artist," and certainly not as a Communist; the ahistorical biases of dominant art history went so far as to decontextualize and practically obliterate the meaning of *Guernica* when it was on view at the Museum of Modern Art in New York, which has traditionally ignored artists' political motives and contexts in its labels and educational materials.)

Sometimes the ferocious seriousness of García's late sixties posters gave way to wicked satire and grim humor, as in *They're Coming!* (cat. no. 5)—the faces of San Francisco city cops on a baseball-like prick spurting blood, or an anonymous black radical gesturing wildly beneath a comic balloon that reads "Down with the Whiteness" (p. 30, cat. no. 10); or the grinning African American Cream of Wheat chef captioned "No More o' This Shit" (p. 32, cat. no. 16) (another rejection of whiteness). In the Decay Dance series (p. 33, cat. nos. 12a–d), a perspectively distorted half-view of Mona Lisa's face slyly obliterates the lower face of the Quaker Oats man— two smiles, either commerce superciliously superseding "high" art, or Latin art creeping up on the Puritan heritage, which was my reading. García says he did the series—a play on "decadence"—in response to his art history courses in school, to Clement Greenberg's insistence on the hierarchy of high over low art, and to the decadence that would ensue if kitsch were triumphant.

These visual puns are still the products of outrage. The Ford logo superimposed on "ABM" documents a case of corporate perfidy (cat. no. 17b): "I'd always thought of Ford as a great and totally beneficent company until I discovered that one of its affiliates, Philco, made components for the nuclear anti-ballistic missile." In the original version of this poster, the humor is spatial: the "ABM" is white on white—a secret void between two red-white-and-blue Ford logos. Expressive space is also the key to the graphically superb *DDT* (p. 34, cat. no. 15a), which shows a little girl running from the large red letters; even more powerful is the same piece, with the same title, without the letters (cat. no. 15b). The child runs from an invisible terror, as the children of farmworkers did then, and still do today; DDT may have been banned, but pesticides and other crop-encouraging pollutants still kill children.

En su máxima expresión, los "retratos ideológicos" son imágenes sagradas, o aún, monumentos a los logros, y a veces sufrimientos, de los personajes retratados, así como ofrendas visuales a su valor intelectual o social. Estilísticamente hay similaridades con los magnificados retratos de Alex Katz, pero la intensidad de los héroes de García contrasta con la más bien blanda intimidad de los amigos de Katz. Aquí los rasgos fisionómicos adquieren un significado proveniente de las vidas de los retratados, con las cuales tenemos cierta familiaridad porque son figuras públicas. A veces García ha reinvertido sus retratos de artistas (Goya, Courbet [p. 40, cat. no. 100], van Gogh, Manet [p. 41, cat. no. 101]) con las apasionadas creencias políticas de las cuales los ha deprivado una historia neutralizada. (En los Estados Unidos, Picasso nunca es vendido como un "artista político," y ciertamente, no como comunista; los prejuicios sin base objetiva de la historia del arte dominante van tan lejos como para sacar de contexto y prácticamente obliterar el significado de *Guernica* cuando estuvo en exhibición en el Museum of Modern Art en Nueva York, el cual tradicionalmente he ignorado los contextos y motivos políticos de los artistas en sus descripciones de las obras y en sus materiales educativos.)

A veces la seriedad feroz de los afiches hechos por García a finales de la década de los sesentas dá paso a una sátira mordaz y a un humor chocante, como en *¡Ellos Vienen!* (They're Coming!) (cat. no. 5)—las caras de los policías de la ciudad de San Francisco reflejadas en un garrote en forma de bate de béisbol borbollando sangre; ó un anónimo activista radical negro gesticulando salvajemente bajo un cómico globo en el que se lee "Abajo con lo Blanco" (Down with the Whiteness) (p. 30, cat. no. 10); ó el sonriente cocinero afroamericano de la Crema de Trigo cuyo pié de grabado dice "No Más de esta Mierda" (No More o' This Shit) (otro rechazo a la cultura anglo-sajona) (p. 32, cat. no. 16). En la serie La Danza del Deterioro, (Decay Dance) (p. 33, cat. nos. 12a–d) una media vista de perspectiva distorsionada del rostro de la Mona Lisa se sobrepone artificiosamente a la parte inferior del rostro del personaje publicitario usado en la promoción e identificación de la avena Quaker—dos sonrisas, sean éstas comercio despreciativamente desplazando al arte "elitista," o arte mediterráneo arrastrándose en la herencia puritana. Al menos, eso fue lo que yo entendí. García dice que hizo esa serie—un drama sobre la "decadencia"—en respuesta a los cursos de historia del arte que recibió en la escuela, a la insistencia de Clement Greenberg en la jerarquía existente entre arte elitista y arte popular, y a la decadencia que se produciría si triunfara un arte pretensioso pero sin ningún valor.

Estas bromas visuales de doble sentido son todavía productos de la ira. El emblema de la Ford superimpuesto en "ABM" documenta un caso de perfidia corpo-

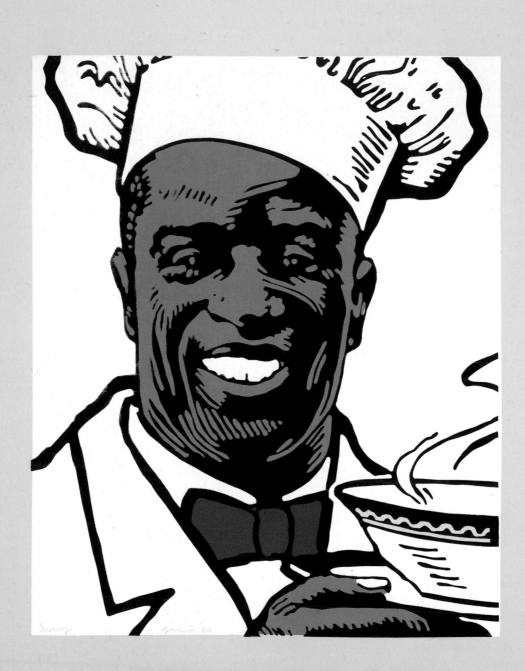

No More o' This Shit., 1969 (cat. no. 16)

Decay Dance, 1969 (cat. no. 12c)

García's posters read like a history of the political events and causes that have marched through our lives from the sixties through the eighties, but they rarely take the obvious path. In *¡Libertad para los Prisoneros Políticas!* [*sic*] Angela Davis looks thoughtful and even vulnerable rather than stereotypically belligerent. The Kent State poster did not, as most did, employ the tragic news photo of a student wailing over a friend's body, but pictures the four victims as happy, smiling youths (p. 34, cat. no. 20). The only image in *Attica is Fascismo* (p. 12, cat. nos. 31a–c) is a grimacing *calavera* that emerges from a profound blackness, and in its more complex

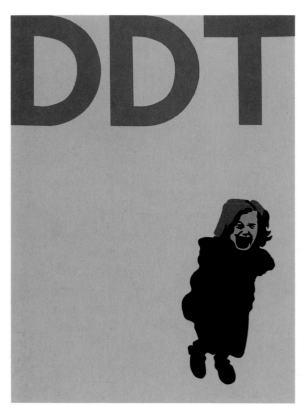

DDT, 1969 (cat. no. 15a)

version both skull and title are intercut with fragments of John Wayne and the United States flag (cat. no. 31c). On the other hand, his memorial for *Los Angeles Times* journalist Rubén Salazar (senselessly killed by a police tear gas projectile shot into the Silver Dollar bar while he was covering one of the biggest Chicano protests against the Vietnam War) depends on no dramatic visuals (p. 35, cat. no. 27). It is the straightforward portrait bust of a decent, respected man whose death is a loss to the community.

Sometimes García's posters are abstract and reductive, eschewing pictorialism altogether. *Free Los Siete* (p. 35, cat. no. 21) is a huge red "7" on an orange background. The poster for the San Francisco State Legal Defense Benefit rock concert (cat. no. 11) appears

rativa (cat. no. 17b): "Yo siempre creí que la Ford era una compañía totalmente beneficiosa hasta que descubrí que una de sus afiliadas, Philco, fabricaba componentes para misiles nucleares antibalísticos." En la versión original de este afiche, el humor es espacial: la ABM es blanca sobre fondo blanco—un vacío secreto entre dos emblemas rojos, blancos, y azules de la Ford. El espacio expresivo es también la clave del gráficamente excelente *DDT* (p. 34, cat. no. 15a), el cual muestra a una pequeña niña corriéndosele a las grandes letras rojas; aún más poderosa es la misma pieza, con el mismo título, sin las letras (cat. no. 15b). La niña huye de un terror invisible,

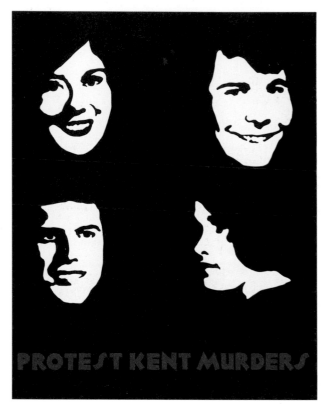

Protest Kent Murders, 1970 (cat. no. 20)

como los hijos de los labradores hacían entonces, y lo hacen aún ahora; DDT pudo haber sido censurado, pero los pesticidas y otros contaminantes utilizados para mejorar las cosechas todavía matan niños.

Los afiches de García se leen como una historia de los eventos y causas políticas que han marchado a través de nuestras vidas desde la década de los sesentas hasta la de los ochentas, pero ellos rara vez toman el camino más obvio. En *¡Libertad para los Prisoneros Políticas!*[*sic*] Angela Davis aparece pensativa y aún vulnerable en vez de lucir estereotípicamente beligerante. El afiche de la Kent State University no empleó, como muchos otros afiches lo hicieron, la trágica fotografía, publicada en periódicos y revistas, de una joven estudiante llorando ante el cadáver de su amigo, sino

non-objective, but its pink-on-yellow form could be smoke rising or a guitar line. *La Raza Cultural Week* (cat. no. 60) is an orange-on-black squared spiral, an ancient Mexican sign for serpent, waves, movement, and perhaps "magic protection against death." *Arte del Barrio* (cat. no. 32) is calculated to confound those with stereotypes of that art. In the striking *Festival del Sexto Sol* the six suns are glyphs or speech scrolls emitted by the Maya profile constructed from the negative white framing space. *3rd World Communications Benefit* (cat. no. 36) is a lively patch of blue and yellow forms reading as three faces (Ho Chi Minh, Frantz Fanon, and Che

fotografías de las cuatro víctimas posando como otros muchachos felices y sonrientes (p. 34, cat. no. 20). La única imagen en *Attica es Fascismo* (Attica is Fascismo) (p. 12, cat. nos. 31a–c) es una doliente *calavera* que emerge de una negrura profunda, y en su versión más compleja, tanto la calavera como el título tienen sobrepuestos fragmentos de la imagen fotográfica de John Wayne y de la bandera de los Estados Unidos (cat. no. 31c). Por el contrario, su pieza en memoria del reportero de *Los Angeles Times*, Rubén Salazar (asesinado insensitivamente con un proyectil de gases lacrimógenos lanzado por la policía dentro de la cantina

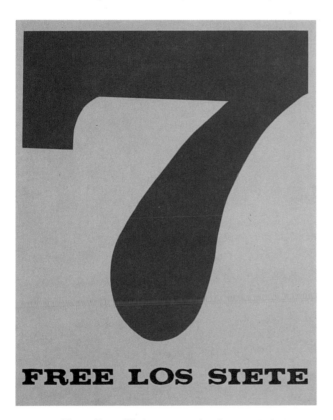

Free Los Siete, 1970 (cat. no. 21)

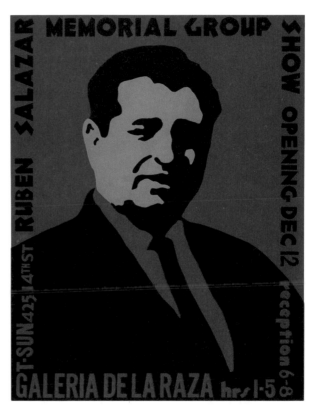

Rubén Salazar Memorial Group Show,

1970 (cat. no. 27)

Guevara), then disintegrating into a visual excitement that parallels the jagged rhythms of the dance concert advertised. Particularly effective are the posters for the NCCHE (National Chicano Council of Higher Education)—a flaming plantlike hand (p. 37, cat. no. 77)—and for the 1971 Galería de la Raza's photography show: *Photographers East/West—Latinos/Chicanos* (which never took place, so the poster became a "conceptual" artwork) (cat. no. 28a). Rather than use the obvious photo image, García simply linked red and blue bands across a yellow ground (the Aztec motif *Ollin* (cat. no. 28b), sign of movement and the current Fifth World), symbolically conveying the coalition achieved among nationally varied Spanish-speaking populations. Confidence in pure form as well as a Matissean exuberance

Silver Dollar mientras estaba cubriendo la primer protesta importante de los chicanos en contra de la guerra del Viet Nam) no depende de ningún dramatismo visual (p. 35, cat. no. 27). Este es un retrato directo y sencillo del busto de un hombre decente, respetado, cuya muerte ha sido una pérdida para la comunidad.

A veces los afiches de García son abstractos y reduccionistas, evadiendo el pictorialismo completamente. *Libertad para los Siete* (Free Los Siete) (p. 35, cat. no. 21) es un gigantesco número siete ubicado sobre un suelo anaranjado. El afiche para el concierto de rock en beneficio de la defensa legal de los estudiantes detenidos en las protestas en la San Francisco State (cat.

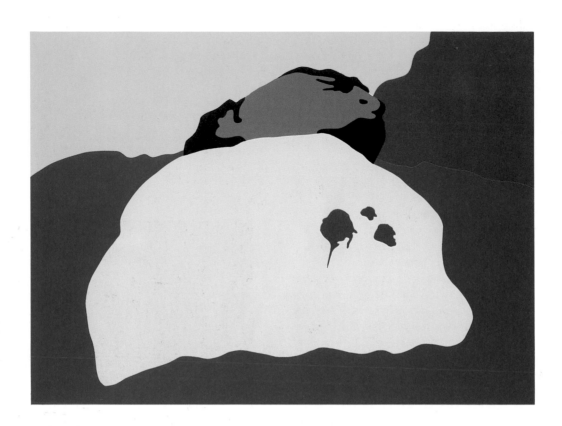

The Bicentennial Art Poster, 1975 (cat. no. 54)

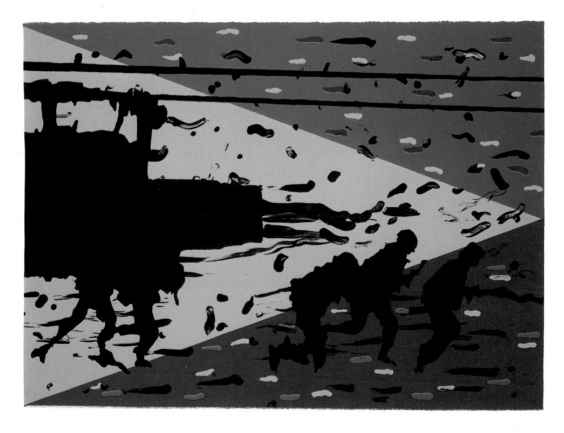

Goliath over David or the U.S. Invasion of Grenada, 1987 (cat. no. 93)

produced the 1973 *Maquey de la Vida* (p. 3, cat. no. 47a)—the agave that is a Mexican symbol of nourishment and life, based on an Edward Weston photo.

Sheer graphic vitality often rescues potentially hackneyed political imagery, as in *El Grito de Rebelde* (cat. no. 52) of 1975—a screaming man, blindfolded and bound against a stake, being executed. (The source photo was taken in Iran under the Shah.) The background is split between gray and black and the shapes of the red/brown face framed by the white shirt and blindfold form a brilliant arrow of light, crossed, and complicated, by the curving lines of rope. Similarly, in what may be García's most important poster of the seventies—*The Bicentennial Art Poster* of 1975 (p. 36, cat. no. 54)—an extraordinary, almost abstract closeup of the foreshortened torso of a murdered man, his moundlike white shirt front flowered with blood, creates an independent memorial to the unheralded martyrs among workers and revolutionaries of color in the two centuries then being widely and commercially celebrated. (The image is used again in 1984 in the pastel *Prometheus under Fire*, in more muted colors, paired with a helicopter). In color and subject the bicentennial poster is related to one of García's major paintings—*Assassination of a Striking Mexican Worker* of 1979—a cropped version of a tragic photograph by Manuel Alvarez Bravo (whom the artist met in 1978) (p. 10, figs. 3, 4), which brings the subject into agonizingly close range in the same dazzling primary colors. (A detail was used in the 1983 poster for the exhibition *A Través de la Frontera* in Mexico City) (cat. no. 80). It seems almost unjust that this image, with its velvety pool draining the lifeblood of a young man, is so beautiful. But perhaps this is the point. "Beauty and death, like life and death, are part of the Mexican ethos," says García. "One does not exist without the other, a union of apparent dissonants that is the whole."

In the eighties García continued to make a tremendously varied group of prints and posters, ranging from the graceful linear profiles of *The Xth Marin City Community Festival* (cat. no. 89), to the poster for the film *Latino* (cat. no. 90)—a partial view of the nude "hero" clutching his dog tags (his identity) in the final scene. In the delicate line etching *Friends of the People* (cat. no. 95), the truncated head of Martin Luther King, Jr., looming over David's *Death of Marat* resembles the lithographs with bipartite compositions and geometric interventions that García had begun to make as spinoffs from the pastels and oils. Lithography offers more textural and painterly surfaces than silkscreen, evident in the 1987 *Goliath over David or the U.S. Invasion of Grenada* (p. 36, cat. no. 93) in which onrushing GIs and backup helicopter are placed against triangular spears of yellow, blue, and red, overlaid with urgent daubs of color. In 1989 García deplored the invasion of Panama with a

no. 11) parece ser no-objetivo, pero sus formas rosadas-sobre-amarillo pudieran ser humo surgiendo hacia el cielo ó una línea de guitarra. *La Semana Cultural de la Raza* (La Raza Cultural Week) (cat. no. 60) es una espiral cuadrada en anaranjado sobre negro, lo que pudiera ser el antiguo símbolo mexicano para la serpiente, ondas, movimiento, y talvez "protección mágica contra la muerte." *Arte del Barrio* (cat. no. 32) ha sido calculado para confundir a aquellos que estereotipan ese arte. En el impactante *Festival del Sexto Sol* los seis soles son antiguos jeroglíficos o símbolos fonéticos emitidos por el perfil maya construídos en el espacio de un

En Celebración de NCCHE 1975—1980,

1979 (cat. no. 77)

contorno en blanco negativo. *Comunicaciones de el Tercer Mundo* (3rd World Communications) (cat. no. 36) es una vívida mancha de formas azules y amarillas que se leen como tres rostros (Ho Chi Minh, Frantz Fanon, y el Che Guevara) y que luego se desintegran en un excitamiento visual a los angulosos ritmos del concierto de danza anunciado en el mismo afiche. Particularmente efectivos son los afiches para el NCCHE (Concilio Nacional Chicano para la Educación Superior)—una llameante mano en forma de planta (p. 37, cat. no. 77)—y para la exhibición de fotografías de la Galería de la Raza: *Fotógrafos Este/Oeste—Latinos/Chicanos* (Photographers East/West—Latinos/Chicanos) en 1971 (la cual nunca se llevó a cabo, por lo que el afiche se

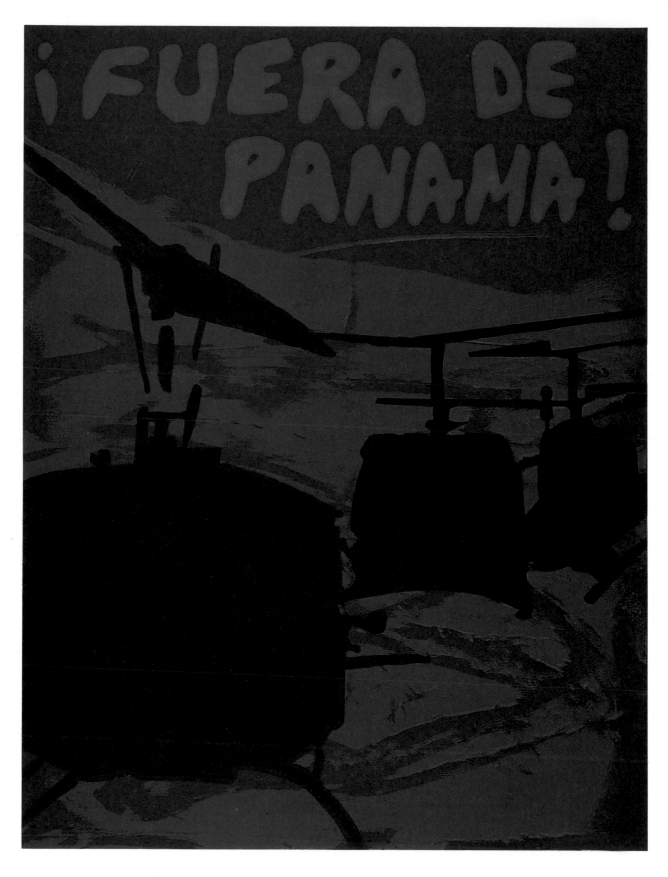

¡Fuera de Panama! 1989 (cat. no. 99)

silkscreen (p. 38, cat. no. 99) that used a more modeled technique and the same rougher lettering style of his 1970 poster, ¡Fuera de Indochina! (p. 39, cat. no. 23).

Courbet and the Vendôme Column III (p. 40, cat. no. 100), and *The Geometry of Manet and the Sacred Heart II* (p. 41, cat. no. 101)—among the most recent works in the show—recall García's art historical studies, which include a master's degree from the University of California at Berkeley in 1981. These can be seen as sophisticated extensions of the earlier ideological portraits. The diptych and triptych forms in themselves provide art historical religious references, and they are

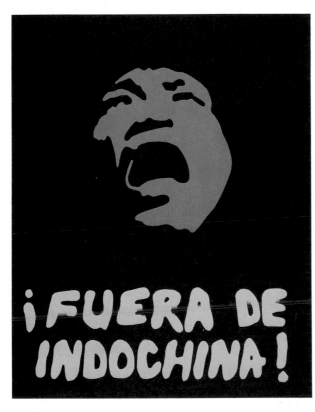

¡Fuera de Indochina! 1970 (cat. no. 23)

also well suited to the artist's bicultural experiences and critical perspective. In the Courbet print, the crumbling Vendôme column (which the artist helped topple during the Commune) looks like a modernist public sculpture, and seems to be coming down on Courbet's head, which indeed it did, in a sense. The triangular cuts on both sides of the Manet print provide the European painter with a cool blue purity to lurk behind, while the yellow and black triangles on the right are merged and overrun with rippling light and baroque form: the heart and Christ's stigmatized hands.

Double framings allow for a more complex use of the image fragmentation that characterizes García's style. The unexpectedly abrupt angles from which single figures are sometimes viewed in the earlier work

convirtió en un trabajo de arte "conceptual" (cat. no. 28a). Más que usar la imagen fotográfica obvia, García simplemente relacionó bandas rojas y azules a través de un terreno amarillo (el motivo azteca *Ollin* (cat. no. 28b), símbolo de movimiento y del Quinto Mundo actual), simbólicamente significando la coalición alcanzada entre poblaciones de habla hispana de diversas nacionalidades. Una confidencia en la forma pura, así como una exhuberancia Matisseana produjeron el *Maguey de la Vida* (p. 3, cat. no. 47a) en 1973—el maguey que es el símbolo mexicano de nutrimiento vital y vida, basado en una fotografía de Edward Weston.

Una completa vitalidad gráfica a menudo rescata a ciertas series de imágenes políticas potencialmente sobreusadas, como en *El Grito de Rebelde* (cat. no. 52) de 1975—un hombre gritando, vendado y amarrado a una estaca, en el acto de ser ejecutado. (La fotografía en la que se basó esta idea fue tomada en Irán, cuando éste estaba bajo el dominio del Shah.) El fondo de este trabajo está dividido entre gris y negro y las formas de la cara roja/café enmarcada por el blanco de la camisa y la venda forman una brillante flecha de luz, cruzada y complicada por las curveantes líneas de una soga. Similarmente, en lo que puede ser el grabado más importante de García en la década de los sententas—*El Bicentenario del Arte del Afiche* (The Bicentennial Art Poster) de 1975 (p. 36, cat. no. 54)—un extraordinario, casi abstracto detalle en perspectiva del torso de un hombre asesinado, cuya camisa blanca en forma de colina que aparece florecida con su sangre en la parte frontal, crea un independiente homenaje póstumo a los anónimos mátires de los trabajadores y revolucionarios de color durante los dos siglos que en ese mismo momento estaban siendo celebrados de manera masiva y comercial. (Esta imagen es usada de nuevo en 1984 en su obra en pastel *Prometeo Bajo el Fuego* (Prometheus under Fire), en colores más apagados, aparejada con un helicóptero.) En color y motivo, el afiche del bicentenario está relacionado a una de las más importantes pinturas de García—*Asesinato de un Trabajador Huelguista Mexicano* (Assassination of a Striking Mexican Worker) de 1979—una versión recortada (lo cual lleva esta obra a un agonizante primer plano) de una trágica fotografía de Manuel Alvarez Bravo (a quién el artista conoció en 1978) (p. 10, figs. 3, 4) en los mismos deslumbrantes colores primarios. (Un detalle de este trabajo fue usado en el afiche de 1983 para la exhibición *A Través de la Frontera* en la ciudad de México [cat. no. 88].) Parece casi injusto que esta imagen, con su charco aterciopelado absorviendo la sangre vital de un joven hombre, sea tan bella. Pero quizás ése es el punto. "Belleza y muerte, así como vida y muerte, son parte del ethos mexicano," dice García. "Uno no existe sin los otros, una unión de disonantes aparentes que es el todo."

En la década de los ochentas, García continuó

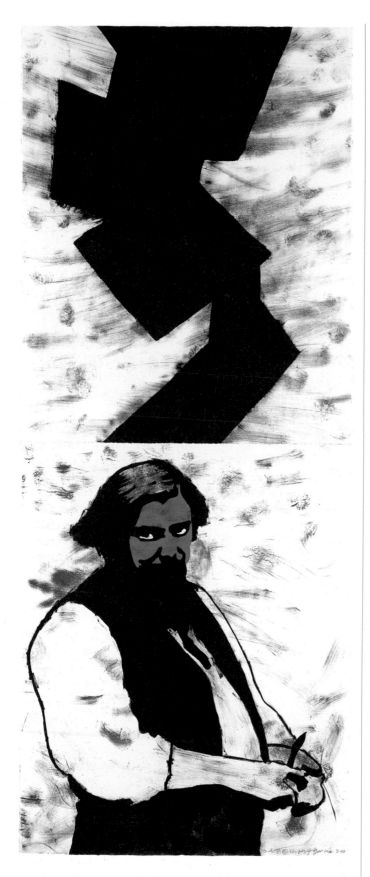

Courbet and the Vendôme Column III,

1990 (cat. no. 100)

producing un grupo tremendamente variado de grabados y afiches, cuya gama va desde los graciosos perfiles lineales de *El X Festival Comunitario de la Ciudad de Marín* (The Xth Marin City Community Festival) (cat. no. 89), hasta el afiche para la película *Latino* (cat. no. 90)—una vista parcial del "héroe" desnudo apretando su collar de identificación del Ejército de los Estados Unidos (su identidad) en la escena final. En el delicado trazo que contornea *Amigos del Pueblo* (Friends of the People) (cat. no. 95), la cabeza cortada de Martin Luther King, Jr., asomándose amenazadoramente sobre la *Cabeza de Marat* de David, asemeja las litografías que García había comenzado a hacer como desarrollo de sus obras en pastel y en sus óleos, con sus composiciones bipartitas y sus intervenciones geométricas. Su litografía ofrece superficies de mas textura y más pictóricas que su serigrafía, lo cual es evidente en su *Goliath sobre David ó la Invasión de Granada por los EEUU* (Goliath over David or the U.S. Invasion of Grenada) de 1987 (p. 36, cat. no. 93) en la que soldados del ejército de los Estados Unidos en acción de ataque y un helicóptero que los refuerza aparecen contra un fondo de espadas triangulares en amarillo, azul, y rojo, cubiertos con urgentes brochazos de color. En 1989, García deploraba la invasión a Panamá con una serigrafía (p. 38, cat. no. 99) que usaba una técnica más modelada y el mismo estilo burdo de letras que usó en su afiche *¡Fuera de Indochina!* en 1970 (p. 39, cat. no. 23).

Courbet y la Columna Vendôme III (p. 40, cat. no. 100), y *La Geometría de Manet y el Sagrado Corazón II* (p. 41, cat. no. 101)—entre los trabajos más recientes en esta exhibición—recuerdan los estudios de García sobre historia del arte, incluyendo un Postgrado en Artes de la University of California en Berkeley en 1981. Estos trabajos más recientes pueden ser vistos como extensiones sofisticadas de sus anteriores retratos ideológicos. Las formas dípticas y trípticas por sí mismas proveen referencias religiosas artístico-históricas, que van en perfecta armonía con las experiencias biculturales y la perspectiva crítica del artista. En el grabado de Courbet, la desfalleciente columna de Vendôme (a la cual el artista ayudó a echar abajo durante la Comuna) parece una escultura pública modernista, y se ve como si se estuviera cayendo sobre la cabeza de Courbet, lo cual sucedió así, en cierto sentido. Los cortes triangulares en ambos lados del grabado de Manet proveen al pintor europeo con una fría pureza azul para amenazar furtivamente desde atrás, mientras los triángulos amarillos y blancos en la derecha están unidos y cubiertos con una luz ondulante y una forma barroca: el corazón y las estigmatizadas manos de Cristo.

Enmarcamientos dobles permiten un uso más complejo de la fragmentación de imágenes que caracteriza al estilo de García. Los inesperados y abruptos ángulos desde los cuales las figuras separadas ó solitarias son a veces vistas en los trabajos anteriores tienen

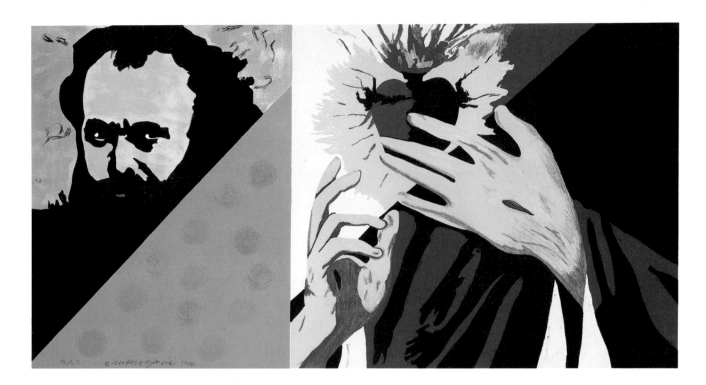

The Geometry of Manet and the Sacred Heart II, 1990 (cat. no. 101)

have spawned multiple cuts and intercuts—another cinematographic influence. Each diptych or triptych is differently divided; the type and amount of space offered each image is a crucial part of the content. One side (in the pastels they are often lopsided, unbalanced sides) might offer a view adapted from the media (often a murdered Third World resister or the Yankee aggressor in and out of his war machines), while the other reasserts cultural autonomy in the form of a colorful mask, a religious figure, a vernacular object or a portrait.

The subjects of the pastels are sometimes much more personal and art-oriented than the posters, but they are also as politically powerful: *Vincent Chin* commemorates the Chinese American man mistaken for Japanese and beaten to death by out-of-work auto workers with a Louisville Slugger as an appalling byproduct of the trade wars; the baseball bat is pictured in a brilliant blur of color, as though swinging through the air. *Libertad y las Américas* and *Hermana a Hermana* incorporate art historical imagery—Delacroix's *Liberty* and the bouquet held by the African attendant to Manet's *Olympia*, juxtaposed against a highly abstracted photo of a slain South African woman. In the pastels, the hand of the artist becomes more visible. (The face of the artist does not. Interestingly, García rarely executes a self-portrait, and when he does, the image is humorous or enigmatic—a crowing cock, the twisting silhouette of a diver.)

For all the success of his "fine art," García has not abandoned the poster form, and his commitment and originality continue to inspire other artists, especially

prolíficos y múltiples secuencias de cortes—otra influencia cinematgráfica. Cada díptico o tríptico es dividido de manera diferente; el tipo y la cantidad de espacio que ofrece cada imagen es una parte crucial del contenido. Un lado (en los trabajos en pastel los lados son a menudo pesados, desbalanceados) puede ofrecer una perspectiva adaptada de los medios masivos de comunicacion social (a menudo un luchador de la resistencia del Tercer Mundo que ha sido asesinado o el agresor yanqui adentro y afuera de sus máquinas de guerra) mientras el otro lado reafirma la autonomía cultural en la forma de una máscara muy colorida, de una figura religiosa, de un objeto vernacular, o de un retrato.

Los motivos de los trabajos en pastel son a veces mucho más personales y artísticos que los afiches, pero también son a menudo tan políticamente poderosos como éstos: *Vincent Chin* conmemora al hombre chino-americano confundido por japonés y golpeado hasta morir por trabajadores desempleados de la industria automotriz con un bate de béisbol marca "Louisville Slugger" como un impactante subproducto de las guerras comerciales; este bate de béisbol está representado en una brillante mancha de color, como si estuviera desplazándose en el aire durante la acción de batear. *Libertad y las Américas* y *Hermana a Hermana* incorporan una serie de imágenes artístico-históricas—la *Libertad* (Liberty) de Delacroix y el ramo de flores sostenido por la sirvienta africana para el *Olimpia* de Manet, contrapuestos a una altamente abstracta fotografía de una mujer surafricana asesinada. En los trabajos en pastel, la mano del artista llega a ser más

younger Chicanos and internationalists. Both branches of Garcia's work—dynamically activist on one hand and esthetically innovative on the other—are finally interwoven and inseparable, each gaining from the other. Together they prove definitively that art and politics do mix, that in the hands of the gifted their marriage can produce marvels.

Notes

1. All quotations lacking sources are from conversations with the artist. For background I am indebted to the excellent texts by Ramon Favela (*The Art of Rupert García* [San Francisco: Chronicle Books and The Mexican Museum, 1986]) and Peter Selz (*Rupert García* [San Francisco: Harcourts Gallery, 1985]). See also the extensive introduction to Shifra Goldman and Tomás Ybarra-Frausto, *Arte Chicano: A Comprehensive Annotated Bibliography of Chicano Art, 1965–1981* (Berkeley: Chicano Studies Library Publications Unit, University of California, 1985).

2. Bob Marvel, *La Voz*, June–July 1985.

3. *Féstival de Flor y Canto* (Los Angeles: University of Southern California, 1976).

4. *Rupert García*, exh. cat. (Stockton, Calif.: Haggin Museum, 1988).

5. Marvel, *La Voz*.

6. Carlos Muñoz, Jr., *Youth, Identity, Power: The Chicano Movement* (London and New York: Verso, 1989), 69.

7. Shifra Goldman, "A Public Voice: Fifteen Years of Chicano Posters," *Art Journal* (Spring 1984):52.

8. Rupert García, "Media Supplement," M.A. thesis, San Francisco State College (now San Francisco State University), 1970.

9. Tomás Ybarra-Frausto, "The Chicano Movement and the Emergence of a Poetic Consciousness," *New Scholar* 6 (1977):82.

10. Manifesto issued by Crusade for Justice, The Chicano Liberation Youth Conference, Denver, "El Plan Espiritual de Aztlán," March 1969, later published in *Aztlán: An Anthology of Mexican American Literature*, ed. Luis Valdéz and Stan Steiner (New York: Vintage Books, 1972), 402–406.

11. *Contracandela* (Havana: Editorial José Martí, forthcoming).

12. Brochure for *La Raza Silkscreen Center: Images of a Community*, 1979.

13. Revised version of interview about Chicano poster art originally published in *The Fifth Sun: Contemporary Chicano and Latino Art* (Berkeley, Calif.: University Art Museum, 1977).

14. *El Tecolote* 2, no. 1 (1981):6–8.

visible. (Pero la cara del artista no los es. Interesantemente, García rara vez ejecuta autorretratos, y cuando lo hace, la imagen es humorística o enigmática—un gallo cantando, la retorcida silueta de un clavadista.

Con todo el éxito de su "fino arte," García no ha abandonado el formato de posters y afiches, y su compromiso y originalidad continúa inspirando a otros artistas, especialmente a chicanos más jóvenes y a internacionalistas. Ambas ramas de la obra de García— dinámicamente activista por un lado, y estéticamente innovativo por el otro—son finalmente indisolubles e inseparables, cada una enriqueciéndose de la otra. Juntas ellas prueban definitivamente que el arte y la política se pueden mezclar, que en las manos de los superdotados esa unión puede producir maravillas.

Traducción de Carlos B. Córdova, Ed.D.
San Francisco State University

Notas

1. Todas las citas en las cuales no aparece la fuente bibliográfica provienen de conversaciones con el artista. Como fuente de información, le debo mucho a los textos de Ramón Favela (*El Arte de Rupert García* [San Francisco: Chronicle Books y The Mexican Museum, 1986]) y a Peter Selz (*Rupert García* [San Francisco: Harcourts Gallery, 1985]). Referirse tambien a Shifra Goldman y Tomás Ybarra-Frausto, *Arte Chicano: A Comprehensive Annotated Bibliography of Chicano Art, 1965–1981* (Berkeley: Chicano Studies Library Publications Unit, University of California, 1985).

2. Bob Marvel, *La Voz*, junio-julio de 1985.

3. *Féstival de Flor y Canto* (Los Angeles: University of Southern California, 1976).

4. *Rupert García*, catálogo de exhibición (Stockton, Calif.: Haggin Museum, 1988.)

5. Marvel, *La Voz*.

6. Carlos Muñoz, Jr., *Youth, Identity, Power: The Chicano Movement* (Londres y Nueva York: Verso, 1989), 69.

7. Shifra Goldman, "A Public Voice: Fifteen Years of Chicano Posters," *Art Journal* (Primavera de 1984): 52.

8. Rupert García, "Media Supplement," tesis de post- grado, San Francisco State College (ahora conocido como San Francisco State University), 1970.

9. Tomás Ybarra-Frausto, "The Chicano Movement and the Emergence of a Poetic Consciousness," *New Scholar* 6 (1977): 82.

10. Manifiesto declarado por la Cruzada para Justicia, Conferencia Juvenil por la Liberación de los Chicanos, Denver, "El Plan Espiritual de Aztlán," marzo de 1969, más tarde publicado en *Aztlán: An Anthology of Mexican American Literature*, editado por Luis Valdéz y Stan Steiner (Nueva York: Vintage Books, 1972), 402–406.

11. *Contracandela* (La Habana: Editorial José Martí, en prensa.)

12. Folleto de *La Raza Silkscreen Center: Images of a Community*, 1979.

13. Versión revisada de una entrevista acerca del arte chicano del afiche publicada originalmente en *The Fifth Sun: Contemporary Chicano and Latino Art* (Berkeley, Calif.: University Art Museum, 1977).

14. *El Tecolote* 2, no. 1 (1981): 6–8.

Catalogue Raisonné

This catalogue of works was prepared by Judith Eurich with the assistance of Armelle Futterman. All works listed here with accession numbers are in the collection of The Fine Arts Museums of San Francisco, Achenbach Foundation of Graphic Arts, Gift of Mr. and Mrs. Robert Marcus.

Dimensions are given with height preceding width. An asterisk (*) denotes works selected for the exhibition accompanying this catalogue.

1. **Untitled** (fragmented nude), 1967

Etching on white wove paper, AP
10 × 8 ⅛ in. (254 × 207 mm) sheet; 8 × 5 ⅞ in. (240 × 149 mm) image
1 AP
1990.1.54

2.* **The War and Children**, 1967

Etching on white wove paper, AP
21 ⅞ × 16 ¼ in. (556 × 412 mm) sheet; 15 ¾ × 11 ⅛ in. (400 × 287 mm) image
1 AP
1990.1.55

3a.* **Black Man and Flag**, fall 1967

Etching and collagraph on Rives BFK paper, AP—black flag, red man
21 ¾ × 22 ½ in. (554 × 570 mm) sheet; 17 ¼ × 18 ½ in. (440 × 472 mm) image
Edition: 5 (1/5—3/5 black flag, red man; 4/5—5/5 red flag, blue man); 1 AP
1990.1.56

3b. **Black Man and Flag**, fall 1967

Etching and collagraph on Rives BFK paper, 4/5
24 ¾ × 21 ⅛ in. (630 × 535 mm) sheet; 17 ¼ × 18 ½ in. (440 × 472 mm) image
1990.1.57

4a. **Black Man with Glasses**, fall 1967

Etching on white wove paper, AP—brown ink
17 ⅞ × 11 ⅜ in. (454 × 287 mm) sheet; 8 × 8 ⅞ in. (201 × 228 mm) image
Edition: 3 APs only—1 brown ink, 1 black ink, 1 red ink (location unknown)
Key image from *Black Man and Flag* (cat. nos. 3a–b)
1990.1.58

4b. **Black Man with Glasses**, fall 1967

Etching on white wove paper, AP—black ink
9 × 15 in. (229 × 382 mm) sheet; 8 × 8 ⅞ in. (201 × 228 mm) image
1990.1.59

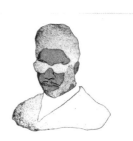

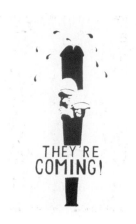

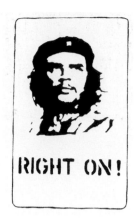

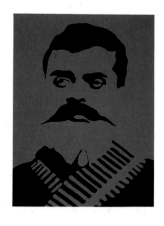

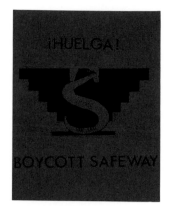

5. They're Coming! 1968

Color silkscreen on white wove paper, AP
35 × 23 1/8 in. (891 × 587 mm) sheet; 23 1/8 × 9 5/8 in. (586 × 246 mm) image
Edition: approx. 50 APs
Printed by the artist during San Francisco State College student strike when a member of SFSC Student and Faculty Poster Workshop
1990.1.60

6.* Right On! 1968

Silkscreen on white wove paper
26 × 20 in. (660 × 508 mm) sheet
Edition: 50
Printed by the artist during San Francisco State College student strike when a member of SFSC Student and Faculty Poster Workshop

7.* Zapata, 1969

Color silkscreen on white wove paper
26 × 20 in. (660 × 508 mm) sheet
Edition: approx. 70
Printed by the artist when a member of the San Francisco Poster Workshop for Mission district newspaper, *La Prensa*
1990.1.62

8.* ¡Huelga! Boycott Safeway, 1969

Color silkscreen on white wove paper
28 × 22 in. (711 × 559 mm) sheet
Edition: approx. 100
Printed by the artist when a member of the San Francisco Poster Workshop for the United Farm Workers Organizing Committee (UFWOC)
1990.1.63

9. Protect the Consumer, Protect the Farmworker, 1969

Color offset lithograph on card-stock paper
20 × 14 in. (508 × 356 mm) sheet; 16 5/8 × 10 1/4 in. (422 × 278 mm) image
Edition: approx. 200
Printed for UFWOC
1990.1.64

10.* Down with the Whiteness, 1969

Color silkscreen on white wove paper
23 1/4 × 19 in. (590 × 483 mm) sheet; 22 5/8 × 18 3/4 in. (576 × 476 mm) image
Edition: 105
Printed by the artist during San Francisco State College student strike when a member of SFSC Student and Faculty Poster Workshop
1990.1.65

11. San Francisco State Legal Defense Benefit, 1969

Color silkscreen on white wove paper
26 × 20 in. (660 × 508 mm) sheet; 17 1/4 × 18 7/8 in. (440 × 480 mm) image
Edition: approx. 75–100
Printed by the artist when a member of the San Francisco Poster Workshop
1990.1.66

12a.* Decay Dance, 1969

Color silkscreen on white wove paper, AP
26 × 20 in. (660 × 508 mm) sheet; 24 7/8 × 19 in. (633 × 483 mm) image
Edition: approx. 50–75; 3 other impressions (listed below)
Printed by the artist when a member of the San Francisco Poster Workshop
1990.1.67

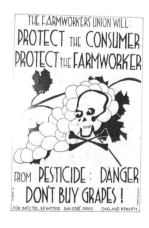

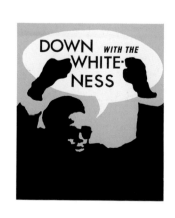

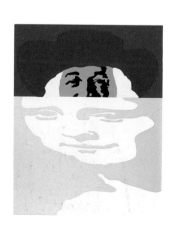

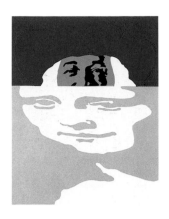

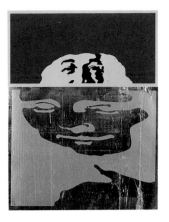

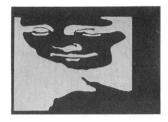

12b. Decay Dance, 1969

Color silkscreen on white wove
paper—all colors but yellow
26 × 20 in. (660 × 508 mm)
sheet; 24 ⁷/₈ × 19 in. (633 × 483
mm) image
1990.1.68

12c. Decay Dance, 1969

Color silkscreen on yellow laid
paper and silver ink—Quaker
printed on yellow paper (top)
and Mona Lisa printed with
silver ink over aluminum com-
mercial paper (bottom)
Diptych: 27 × 19 ³/₄ in. (686
× 502 mm) sheet; top, 10 ³/₈ ×
19 ³/₄ in. (263 × 503 mm) sheet;
bottom, 16 ⁵/₈ × 19 ³/₄ in. (423 ×
502 mm) sheet
1990.1.69

12d. Decay Dance, 1969

Color silkscreen—Mona Lisa
printed with silver ink on red
wove paper
18 × 24 ¹/₈ in. (458 × 613 mm)
sheet; 15 ³/₈ × 19 in. (392 × 482
mm) image
1990.1.70

13.* 14 KT Duke Wayne,
1969

Color silkscreen on white wove
paper, AP
26 × 20 in. (660 × 508 mm)
sheet; 23 ¹/₂ × 19 in. (597 × 482
mm) image
Edition: approx. 50–75
Printed by the artist when a
member of the San Francisco
Poster Workshop
1990.1.71

14.* Dos Hermanos, 1969

Color silkscreen on white wove
paper, 1/many
26 × 20 in. (660 × 508 mm)
sheet; 23 ⁵/₈ × 17 ⁷/₈ in. (602 ×
454 mm) image
Edition: approx. 50–75
Printed by the artist when a
member of the San Francisco
Poster Workshop
1990.1.72

15a.* DDT, 1969

Color silkscreen on white wove
paper, 1/10
26 × 20 in. (660 × 508 mm)
sheet; 23 ⁵/₈ × 17 ¹/₄ in. (602 ×
440 mm) image
Edition: 18; 7 APs
Printed by the artist when a
member of the San Francisco
Poster Workshop and Artes 6,
San Francisco, for *The Pollution
Show*, The Oakland Museum
1990.1.73

15b. DDT, 1969

Color silkscreen on white wove
paper, AP—without "DDT"
26 × 20 in. (660 × 508 mm)
sheet; 23 ⁵/₈ × 17 ¹/₄ in. (602 ×
440 mm) image
1990.1.74

16.* No More o' This Shit.,
1969

Color silkscreen on white wove
paper, 1/many
24 × 18 in. (610 × 459 mm)
sheet; 17 × 13 ⁵/₈ in. (430 × 347
mm) image
Edition: approx. 50–75
Printed by the artist when a
member of the San Francisco
Poster Workshop
1990.1.75

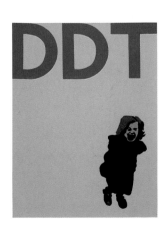

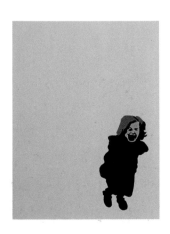

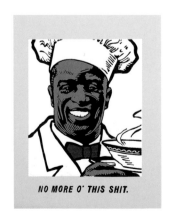

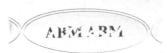

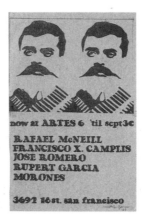

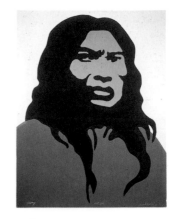

17a.* Ford-ABM-Ford,
 1969

Color silkscreen on white wove
paper
26 1/8 × 22 1/2 in. (665 × 571
mm) sheet; 22 1/8 × 20 5/8 in.
(562 × 523 mm) image
Edition: approx. 50
Printed by the artist when a
member of the San Francisco
Poster Workshop
1990.1.76

17b. ABM-Ford-ABM,
 1969

Color silkscreen on white wove
paper, AP
11 1/8 × 22 5/8 in. (283 × 575
mm) sheet; 6 1/4 × 20 5/8 in. (159
× 526 mm) image
1 AP
1990.1.77

18. Artes 6, 1969

Color offset lithograph on tan
wove paper
12 5/8 × 8 in. (320 × 203 mm)
sheet and image
Edition: approx. 100
Printed and published by Artes
6, San Francisco; key image
from *Zapata* (cat. no. 7)

19a.* Mayan, 1970

Color silkscreen on white wove
paper, 1/many
24 × 18 in. (612 × 458 mm)
sheet and image
Edition: approx. 50–75
Printed by the artist when a
member of the San Francisco
Poster Workshop and Artes 6,
San Francisco
1990.1.78

19b. Mayan, 1970

Silkscreen on red wove
paper, AP
24 × 18 in. (612 × 458 mm)
sheet and image
1 AP

**20.* Protest Kent
 Murders,** 1970

Color silkscreen on white wove
paper
26 1/8 × 20 1/8 in. (664 × 511
mm) sheet; 24 1/8 × 19 in. (611 ×
482 mm) image
Edition: approx. 50–75
Printed by the artist when a
member of the San Francisco
Poster Workshop and Artes 6,
San Francisco, for San Fran-
cisco State College campus
distribution
1990.1.80

21.* Free Los Siete, 1970

Color silkscreen on white wove
paper
26 × 20 in. (660 × 508 mm)
sheet
Edition: approx. 50–75
Printed by the artist when a
member of the San Francisco
Poster Workshop and the Galería
de la Raza, San Francisco, for
the Los Siete Defense Commit-
tee, San Francisco
1990.1.81

**22. Posters by Rupert
 García,** 1970

Color offset lithograph on yellow
wove paper
14 × 8 1/2 in. (355 × 217 mm)
sheet; 12 7/8 × 7 5/8 in. (327 ×
195 mm) image
Edition: approx. 100
Published by Artes 6,
San Francisco
1990.1.82

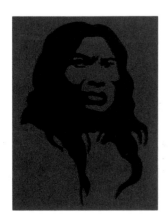

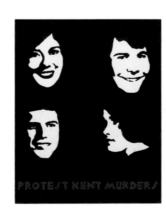

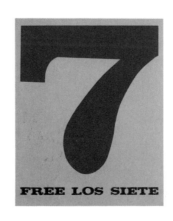

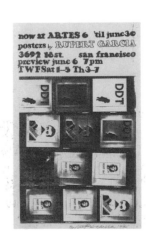

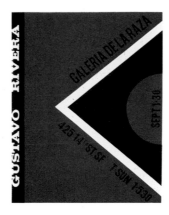

23.* **¡Fuera de Indochina!**
1970

Color silkscreen on white wove
paper
26 × 20 in. (660 × 508 mm)
sheet
Edition: approx. 50–75; 1
impression—black on yellow
paper, location unknown.
Printed by the artist when a
member of the San Francisco
Poster Workshop and the Galería
de la Raza, for the National
Chicano Moratorium, East
Los Angeles
1990.1.83

24. **Chicanos, Cuba y los**
10 Millones, 1970

Color silkscreen on white wove
paper
26 × 20 in. (660 × 508 mm)
sheet
Edition: approx. 75 (location
unknown)
Printed by the artist when a
member of the San Francisco
Poster Workshop and the Galería
de la Raza, for the Galería de la
Raza, San Francisco

25.* **Gustavo Rivera**, 1970

Color silkscreen on white wove
paper
26 × 20 in. (660 × 508 mm)
sheet
Edition: approx. 75
Printed by the artist when a
member of the San Francisco
Poster Workshop and the Galería
de la Raza, for the Galería de la
Raza, San Francisco
1990.1.84

26.* **Mission Film**
Festival, 1970

Color silkscreen on white wove
paper
26 × 20 in. (660 × 508 mm)
sheet
Edition: approx. 75
Printed by the artist when a
member of the San Francisco
Poster Workshop and the Galería
de la Raza, for Mission Mediarts,
San Francisco
1990.1.85

27.* **Rubén Salazar**
Memorial Group
Show, 1970

Color silkscreen on white wove
paper
26 × 20 in. (660 × 508 mm)
sheet
Edition: approx. 75
Printed by the artist when a
member of the San Francisco
Poster Workshop and the Galería
de la Raza, for the Galería de la
Raza, San Francisco
1990.1.86

28a. **Photographers East/**
West—Latinos/
Chicanos, 1971

Color silkscreen on white wove
paper
20 × 26 in. (508 × 660 mm)
sheet; 19 × 25 1/8 in. (482 × 640
mm) image
Edition: approx. 75; 9 impres-
sions without text
Printed by the artist when a
member of the San Francisco
Poster Workshop and the Galería
de la Raza, for the Galería de la
Raza, San Francisco
1990.1.87

28b. **Ollin**, 1971

Color silkscreen on white wove
paper, 5/9—without text
20 × 26 in. (508 × 660 mm)
sheet; 19 × 25 1/8 in. (482 × 640
mm) image
1990.1.88

29a.* **Murals of New Chile**
and Brazilian
Barrio, 1971

Color silkscreen on white wove
paper
20 × 26 in. (508 × 660 mm)
sheet; 18 3/4 × 25 1/8 in. (476 ×
638 mm) image
Edition: approx. 75
Printed by the artist when a
member of the San Francisco
Poster Workshop and the Galería
de la Raza, for the Galería de la
Raza, San Francisco
1990.1.89

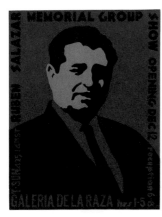

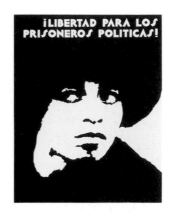

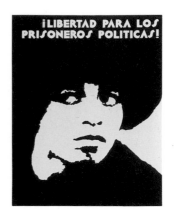

29b. Murals of New Chile and Brazilian Barrio, 1971

Color silkscreen on white wove paper
20 × 26 in. (508 × 660 mm) sheet; 18 ¾ × 25 ⅛ in. (476 × 638 mm) image
Edition: 2 impressions—blue ink
1990.1.90

30a.* ¡Libertad para los Prisoneros Políticas! 1971

Color silkscreen on white wove paper
26 × 20 in. (660 × 508 mm) sheet; 24 ⅝ × 19 in. (625 × 485 mm) image
Edition: approx. 100
Printed by the artist when a member of the San Francisco Poster Workshop and the Galería de la Raza, for the National Committee to Free Angela Davis
1990.1.91

30b. ¡Libertad para los Prisoneros Políticas! 1971

Silkscreen on white Rives BFK paper, AP
29 ⅛ × 22 ⅛ in. (741 × 562 mm) sheet; 24 ⅝ × 19 in. (625 × 485 mm) image
An unknown number of black ink on white paper posters were issued in 1971 in Los Angeles by an unidentified printer and publisher.
1990.1.92

30c. ¡Libertad para los Prisoneros Políticas! 1971

Silkscreen on yellow laid paper
29 × 22 in. (737 × 558 mm) sheet; 24 ⅝ × 19 in. (625 × 485 mm) image
1 impression only
1990.1.93

30d. ¡Libertad para los Prisoneros Políticas! 1971

Color silkscreen on white wove paper
24 × 18 in. (609 × 458 mm) sheet and image
1 impression only with black ink on full-color print of *14 KT Duke Wayne* (cat. no. 13)
1990.1.94

30e. ¡Libertad para los Prisoneros Políticas! 1969/70

Silkscreen on white wove paper, AP
23 ¾ × 18 ⅝ in. (604 × 473 mm) sheet and image
1 impression only with *¡Libertad para los Prisoneros Políticas!* and key image from *Dos Hermanos* (cat. no. 14)—black ink on white paper
1990.1.95

31a.* Attica is Fascismo, 1971

Color silkscreen on white wove paper
26 × 20 in. (660 × 508 mm) sheet; 24 ¾ × 19 in. (630 × 484 mm) image
Edition: approx. 100; 2 other impressions
Printed by the artist when a member of the San Francisco Poster Workshop and the Galería de la Raza, for the Prisoners Union, San Francisco
1990.1.96

31b. Attica is Fascismo, 1971

Silkscreen on white wove paper
26 × 20 in. (660 × 508 mm) sheet; 24 ¾ × 19 in. (630 × 484 mm) image
1990.1.97

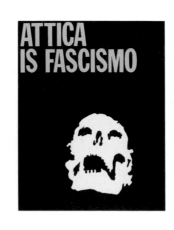

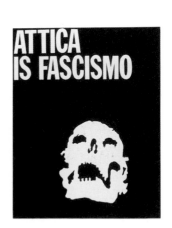

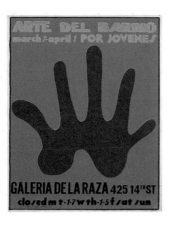

31c. Attica is Fascismo, 1971

Color silkscreen on white wove paper
26 × 20 in. (660 × 508 mm) sheet
The key image of this poster is in black ink over full-color *14 KT Duke Wayne* (cat. no. 13).

32.* Arte del Barrio, 1971

Color silkscreen on white wove paper
26 × 20 in. (660 × 508 mm) sheet; 25 1/8 × 19 1/4 in. (638 × 487 mm) image
Edition: approx. 75
Printed by the artist when a member of the San Francisco Poster Workshop and the Galería de la Raza, for the Galería de la Raza, San Francisco
1990.1.98

33.* The Mexican Film Poster, 1971

Color silkscreen on white wove paper
26 × 20 in. (660 × 508 mm) sheet; 25 1/8 × 19 1/4 in. (637 × 490 mm) image
Edition: approx. 75
Printed by the artist when a member of the San Francisco Poster Workshop and the Galería de la Raza, for the Galería de la Raza, San Francisco
1990.1.99

34. The Sacred Well of Chichén Itzá, 1971

Color silkscreen on white wove paper, AP
26 × 20 in. (660 × 508 mm) sheet; 24 7/8 × 19 1/2 in. (632 × 495 mm) image
Edition: approx. 75
Printed by the artist when a member of the San Francisco Poster Workshop and the Galería de la Raza, San Francisco, for the San Francisco State College departments of anthropology, art, and La Raza studies
1990.1.100

35a. J.C. Orozco, 1972

Color silkscreen on white wove paper
26 × 30 in. (660 × 762 mm) sheet
Edition: 123 for the Galería de la Raza's 1973 collective calendar (September); approx. 20 other impressions without the month and days and 2 other impressions hand-colored with pastel (cat. no. 35c)

35b.* J.C. Orozco, 1972

Color silkscreen on white wove paper, AP
26 × 20 in. (660 × 508 mm) sheet; 17 × 19 in. (432 × 482 mm) image
Approx. 20 impressions without the month and days
1990.1.102

35c. J.C. Orozco, 1972/75

Color silkscreen and pastel on white wove paper
14 3/8 × 18 1/8 in. (362 × 460 mm) sheet and image
2 impressions only
1990.1.181

36.* 3rd World Communications Benefit, 1972

Color silkscreen on white wove paper
26 × 20 in. (660 × 508 mm) sheet; 24 7/8 × 19 1/8 in. (634 × 486 mm) image
Edition: approx. 75; 9 impressions without text (location unknown)
Printed by the artist when a member of the San Francisco Poster Workshop, the Galería de la Raza, Ediciónes Pocho Che, and Third World Communications Collective, San Francisco, for Third World Communications
1990.1.103

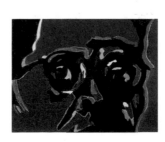

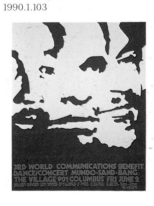

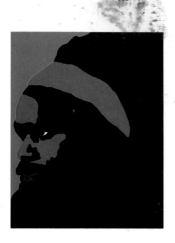

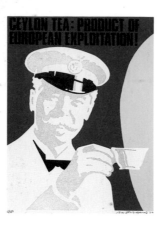

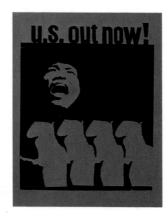

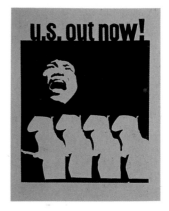

37.* Cambios, 1972

Color silkscreen on white wove paper, AP
26 × 20 in. (660 × 508 mm) sheet; 24 ⁷/₈ × 19 in. (633 × 484 mm) image
Edition: approx. 75
Printed by the artist when a member of the San Francisco Poster Workshop and the Galería de la Raza, San Francisco
1990.1.104

38.* Ceylon Tea: Product of European Exploitation! 1972

Color silkscreen on white wove paper, AP
26 × 20 in. (660 × 508 mm) sheet; 25 × 18 ⁷/₈ in. (637 × 479 mm) image
Edition: approx. 75
Printed by the artist when a member of the San Francisco Poster Workshop, the Galería de la Raza, Third World Communications, and Ediciónes Pocho Che, San Francisco
1990.1.105

39a.* U.S. Out Now! 1972

Silkscreen on orange wove paper
23 ⅛ × 17 ½ in. (588 × 445 mm) sheet; 19 ³/₈ × 15 in. (492 × 382 mm) image
Edition: approx. 15; some with black ink on orange paper (cat. no. 39a) and others with black ink on yellow paper (cat. no. 39b)
Printed and designed with members of Third World Communications Collective, when a member of the Galería de la Raza, Ediciónes Pocho Che, and Third World Communications, San Francisco
1990.1.106

39b. U.S. Out Now! 1972

Silkscreen on yellow wove paper
23 ⅛ × 17 ⅝ in. (588 × 448 mm) sheet; 19 ³/₈ × 15 in. (492 × 382 mm) image
1990.1.107

40. The Struggle Is Here, 1972

Color silkscreen on yellow wove paper
17 ½ × 23 ⅛ in. (445 × 588 mm) sheet; 15 ³/₄ × 20 in. (401 × 507 mm) image
Edition: approx. 15
Printed and designed with members of Third World Communications Collective when a member of the Galería de la Raza, Ediciónes Pocho Che, and Third World Communications, San Francisco; signed by the artist and Jim Dong
1990.1.108

41.* Allende, 1973

Silkscreen on white wove paper
26 × 20 in. (660 × 508 mm) sheet
Edition: approx. 75
Printed by the artist when a member of the Galería de la Raza, Ediciónes Pocho Che, and Third World Communications, San Francisco
1990.1.109

42.* Perromictlan, 1973

Color silkscreen on white wove paper, AP
26 × 20 in. (660 × 508 mm) sheet; 24 ⁷/₈ × 19 ⅛ in. (634 × 486 mm) image
Edition: approx. 25
Printed by the artist when a member of the Galería de la Raza, Ediciónes Pocho Che, and Third World Communications, San Francisco
1990.1.110

43.* ¡Cesen Deportación! 1973

Color silkscreen on white wove paper
20 × 26 in. (508 × 660 mm) sheet; 18 ³/₄ × 25 ⅛ in. (476 × 638 mm) image
Edition: approx. 75
Printed by the artist when a member of the Galería de la Raza, Ediciónes Pocho Che, and Third World Communications, San Francisco, for El Centro de Acción Social Autónoma—Hermandad de Trabajadores, Los Angeles
1990.1.111

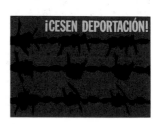

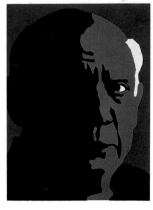

44. Anthony Russo on Crisis '73, 1973

Offset lithograph on white wove paper
22 × 16 ⅞ in. (559 × 429 mm) sheet and image
Edition: approx. 250
Published by the Associated Students, College of Marin, and the 6th District Coalition, Marin, Calif.
1990.1.112

45. Salvador Allende/ Pablo Neruda Memorial Poetry Reading, 1973

Offset lithograph on white wove paper
24 × 18 in. (610 × 458 mm) sheet; 22 ¼ × 16 ⅞ in. (564 × 429 mm) image
Edition: approx. 500
Published by Ediciónes Pocho Che and Comunicación Aztlán, San Francisco
1990.1.113

46a.* Pablo Picasso, 1973

Color silkscreen on white wove paper, AP
26 × 20 in. (660 × 508 mm) sheet; 24 ¾ × 19 in. (631 × 482 mm) image
Edition: approx. 75; 1 impression hand-colored with pastel (cat. no. 46b)
Printed by the artist as a member of the Galería de la Raza, Ediciónes Pocho Che, and Third World Communications, San Francisco
1990.1.114

46b. Pablo Picasso, 1974/75

Color silkscreen and pastel on white wove paper
26 × 20 in. (660 × 508 mm) sheet; 25 × 19 ¼ in. (635 × 490 mm) image
1 impression only

47a.* Maguey de la Vida, 1973

Color silkscreen on white wove paper, AP
20 × 26 in. (508 × 660 mm) sheet; 18 ⅞ × 25 ¼ (478 × 638 mm) image
Edition: approx. 75; 1 impression hand-colored with pastel (cat. no. 47b)
Printed by the artist as a member of the Galería de la Raza, Ediciónes Pocho Che, and Third World Communications, San Francisco
1990.1.116

47b. Maguey de la Vida, 1973/78

Color silkscreen and pastel on white wove paper
20 × 26 in. (508 × 660 mm) sheet
1 impression only

48. Festival del Sexto Sol, 1974

Color offset lithograph on white wove paper
24 × 18 in. (610 × 457 mm) sheet; 23 × 16 ½ in. (584 × 419 mm) image
Edition: approx. 500, all signed by artist in pencil
Published by Ediciónes Pocho Che, San Francisco
1990.1.117

49a. David Alfaro Siqueiros, 1974

Color silkscreen on white wove paper
22 × 20 in. (559 × 508 mm) image
Edition: 110 for the Galería de la Raza's 1974 collective calendar (October)
Image reprinted in 1977 by Public Art Workshop, Chicago, to raise funds for translating Siqueiros's book, *Como Se Pinta un Mural*, into English

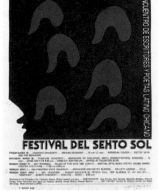

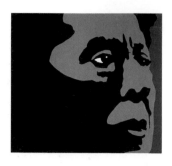

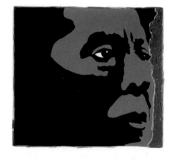

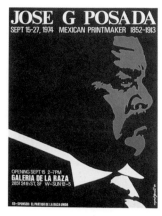

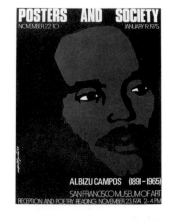

49b.* **David Alfaro Siqueiros**, 1974

Color silkscreen on white wove paper
20 × 22 in. (508 × 559 mm) sheet
Approx. 20 impressions without the month and days
1990.1.180

49c. **David Alfaro Siqueiros**, 1974/82

Color silkscreen and pastel on white wove paper, AP
20 × 22 in. (508 × 559 mm) sheet; 18 3/8 × 19 1/4 in. (467 × 489 mm) image
1 impression only
1990.1.119

50.* **José G. Posada**, 1974

Color offset lithograph on white wove paper
21 × 15 7/8 in. (533 × 402 mm) sheet; 20 1/4 × 14 3/4 in. (513 × 375 mm) image
Edition: approx. 250
Published by the Galería de la Raza, San Francisco; image of Posada after Leopoldo Méndez's linocut, *Posada en su Taller*, n.d.
1990.1.120

51a.* **Posters and Society**, 1974

Color offset lithograph on white wove paper
21 1/4 × 15 7/8 in. (539 × 403 mm) sheet; 20 1/8 × 14 7/8 in. (511 × 377 mm) image
Edition: approx. 500
Published by the San Francisco Museum of Art (now the SF Museum of Modern Art)
1990.1.121

51b. **Posters and Society**, 1974

Color offset lithograph on white wove paper
22 5/8 × 17 1/2 in. (575 × 445 mm) sheet; 20 1/8 × 14 7/8 in. (511 × 376 mm) image
Approx. 10 impressions with blue ink
1990.1.122

52.* **El Grito de Rebelde**, 1975

Color silkscreen on white wove paper
26 × 20 in. (660 × 508 mm) sheet
Edition: approx. 75
Printed by the artist when a member of the Galería de la Raza, San Francisco
1990.1.123

53. **Juan Fuentes y Rupert García**, 1975

Offset lithograph on tan wove paper
17 3/8 × 23 1/2 in. (446 × 597 mm) sheet
Edition: approx. 250
Published by the Galería de la Raza, San Francisco; co-designed with Juan Fuentes; image of Posada after Leopoldo Méndez's linocut, *Posada en su Taller*, n.d.
1990.1.124

54.* **The Bicentennial Art Poster**, 1975

Color silkscreen on white wove paper, AP
20 × 26 in. (508 × 660 mm) sheet; 18 7/8 × 25 in. (478 × 637 mm) image
Edition: approx. 75
Printed by the artist when a member of the Galería de la Raza, San Francisco; image after a work by David G. Bragin
1990. 1.125

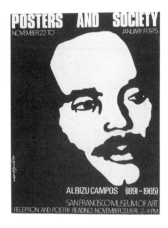

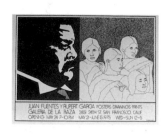

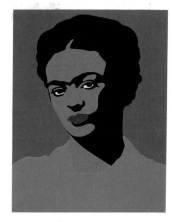

55. Juan Fuentes y Rupert García, 1975

Offset lithograph on tan wove paper
17 ½ × 22 ½ in. (445 × 571 mm) sheet
Edition: approx. 250
Published by the Jackson Street Gallery, San Francisco; co-designed with Juan Fuentes
1990.1.126

56a. El Tecolote Benefit: 5th Anniversary Celebration, 1975

Color offset lithograph on white wove paper
17 × 11 in. (432 × 280 mm) sheet; 15 ³/₈ × 10 in. (390 × 252 mm) image
Edition: approx. 250
Published by *El Tecolote*, San Francisco
1990.1.127

56b. El Tecolote Benefit: 5th Anniversary Celebration, 1975

Offset lithograph on yellow wove paper
14 × 8 ½ in. (356 × 216 mm) sheet; 12 ¼ × 8 in. (313 × 203 mm) image
Edition: approx. 250, half black ink on yellow paper, half black ink on blue paper
Published by *El Tecolote*, San Francisco
1990.1.128

57.* Frida Kahlo, 1975

Color silkscreen on white wove paper
23 × 17 ½ in. (584 × 445 mm) sheet
Edition: 125 for the Galería de la Raza's 1975 collective calendar; approx. 20 impressions made without the name of month and days
Printed by the artist when a member of the Galería de la Raza, for the Galería de la Raza, San Francisco
1990.1.129

58.* The Mexican Museum Inaugural Exhibit of Mexican and Chicano Art, 1976

Color offset lithograph on white wove paper
22 ¾ × 17 in. (578 × 432 mm) sheet
Edition: approx. 500
Published by The Mexican Museum, San Francisco; rooster designed after the Mexican folk artist Candelario Medrano (1914–1985?)
1990.1.130

59. KPFA 1976 Marathon, 1976

Color offset lithograph on white wove paper
22 ¾ × 15 in. (579 × 381 mm) sheet; 21 ³/₈ × 13 ½ in. (543 × 349 mm) image
Edition: 500
Published by KPFA, Berkeley, Calif.; image of woman's face taken from the poster *Chicanos, Cuba y los 10 Millones* (cat. no. 24)
1990.1.131

60.* La Raza Cultural Week, 1976

Color silkscreen on laid paper
23 ⅛ × 17 ½ in. (588 × 445 mm) sheet; 22 ¼ × 17 ⅛ in. (576 × 436 mm) image
Edition: approx. 100
Published by La Raza Studies, San Francisco State University; printed by La Raza Silkscreen Center, San Francisco
1990.1.132

61.* False Promises: Nos Engañaron, 1070

Color offset lithograph on white wove paper
21 ¼ × 13 ⅞ in. (538 × 353 mm) sheet and image
Edition: approx. 500
Published by the San Francisco Mime Troupe
1990.1.133

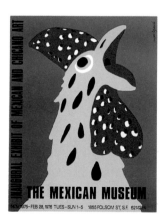

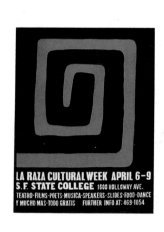

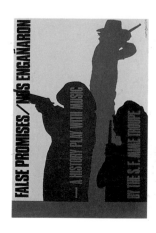

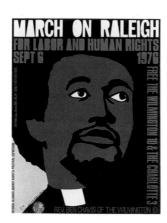

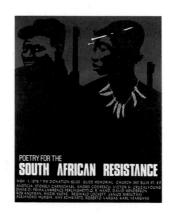

62.* Kami Kaze, 1976
Color offset lithograph on white wove paper
11 × 8 ½ in. (280 × 216 mm) sheet and image
Edition: approx. 200
Published by Kami Kaze, San Francisco
1990.1.134

63. March on Raleigh, 1976
Color offset lithograph on white wove paper
22 ½ × 17 in. (571 × 432 mm) sheet; 21 × 15 ¾ in. (535 × 398 mm) image
Edition: approx. 500
Published by the National Alliance against Racist and Political Repression, New York City
1990.1.135

64.* Poetry for the South African Resistance, 1976
Color offset lithograph on white wove paper
23 ⅛ × 17 ½ in. (587 × 445 mm) sheet; 21 ⅞ × 16 ⅞ in. (555 × 429 mm) image
Edition: approx. 500
Image of male miner in poster created by Richard F. Brown
1990.1.136

65. Human Rights Day, 1975/76
Color offset lithograph on buff wove paper
22 ¾ × 17 ½ in. (603 × 445 mm) sheet; 20 ⅝ × 15 ⅞ in. (524 × 403 mm) image
Edition: approx. 15,000
Published by Amnesty International U.S.A.; design for poster based upon *El Grito de Rebelde* (cat. no. 52)
1990.1.137

66.* Mozambique Educational Fund, 1977
Color offset lithograph on white wove paper
22 ¼ × 17 ¼ in. (566 × 439 mm) sheet; 21 ¾ × 16 ¼ in. (554 × 425 mm) image
Edition: approx. 500
Published by the Mozambique Educational Fund, Minneapolis; key image from *Dos Hermanos* (cat. no. 14)
1990.1.138

67.* KPFA 1977 Marathon, 1977
Color offset lithograph on white wove paper
22 ¾ × 15 in. (579 × 381 mm) sheet; 21 ⅜ × 14 ⅛ in. (543 × 359 mm) image
Edition: approx. 500
Published by KPFA, Berkeley, Calif.; profile on left taken from *The Sacred Well of Chichén Itzá* (cat. no. 34)
1990.1.139

68. Chicano Research as a Catalyst for Social Change, 1977
Color offset lithograph on white wove paper
20 × 15 in. (508 × 381 mm) sheet; 19 ¼ × 14 ¼ in. (490 × 364 mm) image
Edition: approx. 500
Published by the National Association of Chicano Social Scientists, Berkeley, Calif.
1990.1.140

69. Bari Scott's July, 1977
Offset lithograph on white wove paper
14 × 8 ½ in. (356 × 216 mm) sheet; 13 ½ × 8 in. (343 × 203 mm) image
Edition: approx. 250
Published by KPFA, Berkeley, Calif.
1990.1.141

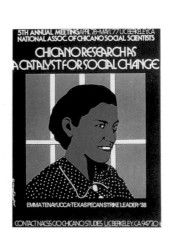

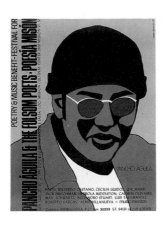
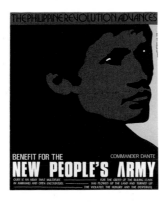
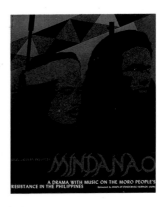
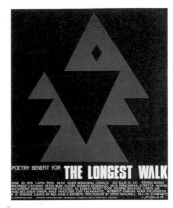

70.* **Pancho Aguila &
the Folsom Prison
Poets—Poesía
Mis[i]ón**, 1977

Color offset lithograph on white
wove paper
22 ⁵/₈ × 17 ⁵/₈ in. (575 × 448
mm) sheet; 21 ⁵/₈ × 16 ¹/₈ in.
(550 × 409 mm) image
Edition: approx. 500
Published by the Folsom Prison
Poets—Poesía Misión, San
Francisco
1990.1.142

71. **Benefit for the New
People's Army:
Commander Dante**,
1978

Color offset lithograph on white
wove paper
20 ³/₄ × 17 in. (528 × 432 mm)
sheet; 20 ¹/₈ × 16 ¹/₂ in. (511 ×
420 mm) image
Edition: approx. 500
Published by KDP, Union of
Democratic Filipinos, San
Francisco
1990.1.143

72.* **Mindanao**, 1978

Color offset lithograph on white
wove paper
22 ¹/₈ × 17 ¹/₄ in. (562 × 439
mm) sheet; 21 ¹/₄ × 16 ³/₄ in.
(538 × 422 mm) image
Edition: approx. 500
Published by KDP, Union of
Democratic Filipinos, San
Francisco
1990.1.144

73.* **Poetry Benefit for
the Longest Walk**,
1978

Color offset lithograph on white
wove paper
22 ¹/₂ × 17 ¹/₂ in. (571 × 445
mm) sheet; 21 × 16 ³/₄ in. (534
× 423 mm) image
Edition: approx. 500
Published by the American
Indian Bay Area Interagency
and the American Indian Adult
Education Program
1990.1.145

74.* **The 4th Annual Marin
City Community
Festival**, 1978

Color offset lithograph on white
wove paper
16 ³/₄ × 11 in. (425 × 279 mm)
sheet; 16 ¹/₄ × 10 in. (414 × 255
mm) image
Edition: approx. 500
Published by the Marin City
Festival Committee, Marin City,
Calif.
1990.1.146

75a.* **Homenaje a Frida
Kahlo**, 1978

Color silkscreen on white wove
paper
23 ¹/₈ × 17 ¹/₂ in. (587 × 445
mm) sheet; 22 ³/₄ × 16 ³/₄ in.
(578 × 427 mm) image
Edition: approx. 300; 1 impres-
sion hand-colored with pastel
Published by the Galería de la
Raza, La Raza Silkscreen Cen-
ter, San Francisco, and the
artist; printed by La Raza
Silkscreen Center
1990.1.147

75b. **Homenaje a Frida
Kahlo**, 1978

Color silkscreen and pastel on
white wove paper
23 × 17 ¹/₂ in. (584 × 445 mm)
sheet
1 impression only

76.* **The Mexican
Museum**, 1978

Color offset lithograph on white
wove paper
22 ¹/₂ × 17 ¹/₄ in. (571 × 439
mm) sheet
Edition: approx. 500
Published by The Mexican
Museum, San Francisco
1990.1.148

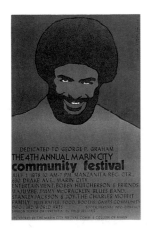
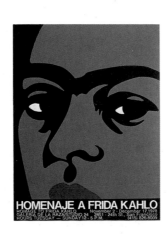
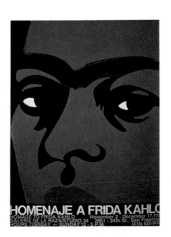

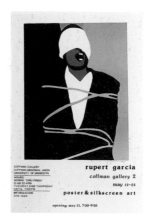

77.* **En Celebración de NCCHE 1975–1980,** 1979

Color silkscreen on white wove paper
23 × 17 ½ in. (584 × 445 mm) sheet
Edition: approx. 300
Published by the National Council on Chicano Higher Education; printed by the La Raza Silkscreen Center, San Francisco
1990.1.149

78. **Chicano Week: University of Minnesota,** 1980

Color offset lithograph on white wove paper
22 ½ × 14 in. (572 × 355 mm) sheet; 21 ¼ × 12 ⅝ in. (540 × 322 mm) image
Edition: approx. 250
Published by the University of Minnesota; key image from *Perromictlan* (cat. no. 42)
1990.1.150

79. **Rupert García: Poster and Silkscreen Art,** 1980

Color offset lithograph on white wove paper
22 ½ × 14 in. (572 × 355 mm) sheet; 20 ⅞ × 12 ⅞ in. (530 × 327 mm) image
Edition: approx. 250
Published by the Chicano Studies Department and the College of Liberal Arts, University of Minnesota; image based on *El Grito de Rebelde* (cat. no. 52) and *Human Rights Day* (cat. no. 65).
1990.1.151

80.* **6th Marin City Community Festival,** 1980

Color offset lithograph on white wove paper
22 × 17 ⅝ in. (559 × 448 mm) sheet and image
Edition: approx. 500
Published by the Marin City Festival Committee, Marin City, Calif.
1990.1.152

81.* **Black to Roots Music Festival,** 1980

Color silkscreen on white wove paper
23 ⅛ × 17 ½ in. (588 × 445 mm) sheet; 22 ⅝ × 16 ¾ in. (575 × 427 mm) image
Edition: approx. 250
Published by the Associated Students, Performing Arts, San Francisco State University; printed by the La Raza Silkscreen Center, San Francisco
1990.1.153

82. **The 7th Marin City Community Festival,** 1981

Color offset lithograph on white wove paper
22 × 17 ½ in. (560 × 445 mm) sheet and image
Edition: approx. 500
Published by the Marin City Festival Committee, Marin City, Calif.
1990.1.154

83.* **Free Nelson Mandela and All South African Political Prisoners,** 1981

Color offset lithograph on white wove paper
22 ½ × 17 ½ in. (572 × 445 mm) sheet and image
Edition: 500
Published by the Liberation Support Movement and the United Nations Centre against Apartheid
1990.1.155

84. **Tala-Arawang Bayan: 1982 People's Calendar,** 1981

Color offset lithograph on white wove paper
22 × 17 ⅝ in. (559 × 447 mm) sheet and image
Edition: approx. 500
Published by KDP, Union of Democratic Filipinos
1990.1.156

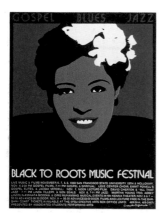

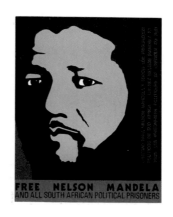

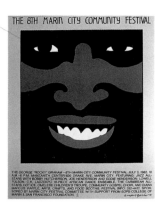

85. Rupert García, 1981

Offset lithograph on tan wove paper
23 × 15 in. (585 × 382 mm) sheet; 20 ⅞ × 11 ¼ in. (532 × 283 mm) image
Edition: approx. 250
Published by the University Art Gallery, State University of New York at Binghamton
1990.1.157

86.* The 8th Marin City Community Festival, 1982

Color offset lithograph on white wove paper
22 × 17 ½ in. (560 × 445 mm) sheet and image
Edition: approx. 500
Published by the Marin City Festival Committee, Marin City, Calif.
1990.1.158

87a. The 9th Marin City Community Festival, 1983

Color offset lithograph on white wove paper
22 × 17 ½ in. (560 × 445 mm) sheet and image
Edition: approx. 500
Published by the Marin City Festival Committee, Marin City, Calif.
1990.1.159

87b. The 9th Marin City Community Festival, 1983

Offset lithograph on yellow wove paper
11 × 8 ½ in. (280 × 217 mm) sheet; 10 × 6 ¼ in. (253 × 158 mm) image
Edition: approx. 250
Published by the Marin City Festival Committee, Marin City, Calif.
1990.1.160

88.* A Través de la Frontera, 1983

Color offset lithograph on white wove paper
26 ¾ × 17 ½ in. (680 × 445 mm) sheet
Edition: approx. 500
Published by the Centro de Estudios Económicas y Sociales del Tercer Mundo, Mexico, D.F.
The image is a detail from the artist's 1979 pastel *Assassination of a Striking Mexican Worker*, after *Obrero en Huelga, Asesinado* (Worker on Strike, Murdered), 1934, a photograph by Manuel Alvarez Bravo (see fig. 3, p. 10).
1990.1.161

89.* The Xth Marin City Community Festival, 1984

Color offset lithograph on white wove paper
22 × 17 ½ in. (563 × 445 mm) sheet and image
Edition: approx. 500
Published by the Marin City Festival Committee, Marin City, Calif.
1990.1.162

90.* Latino, 1985

Color silkscreen on white wove paper (signed)
26 × 20 in. (660 × 508 mm) sheet; 25 ⅜ × 19 ¼ in. (646 × 489 mm) image
Edition: two editions—100 signed and editioned on 100% rag paper; 200, not signed or numbered
Published by Latino Productions, Los Angeles; printed by Mission Gráfica, San Francisco
1990.1.163

91.* The Mexican Museum, 1985

Color silkscreen on white wove paper
26 × 20 in. (660 × 508 mm) sheet; 25 ⅜ × 19 ¼ in. (644 × 489 mm) image
Edition: 200
Published by The Mexican Museum, San Francisco; printed by Mission Gráfica
1990.1.164

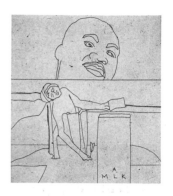

92.* Rupert García: A Survey Exhibition, 1986

Color offset lithograph on white wove paper
26 × 20 in. (660 × 508 mm) sheet and image
Edition: approx. 1,000
Published by The Mexican Museum, San Francisco; the image is of the artist's 1985 pastel *The Horse in Man*, after *Wooden Horse*, 1928, a photograph by Manuel Alvarez Bravo
1990.1.165

93.* Goliath over David or the U.S. Invasion of Grenada, 1987

Color lithograph on Rives BFK paper, 2/100
22 ½ × 30 ¼ in. (572 × 769 mm) sheet and image
Edition: 100
Published by MARS Artspace, Phoenix, Ariz.; printed by Sette Publishing Co., Tempe, Ariz.; the image is a detail from the artist's 1987 oil painting of the same title
1990.1.166

94. Rupert García, 1987

Color offset lithograph on white wove paper
13 ⁵/₈ × 18 ³/₈ in. (346 × 469 mm) sheet; 8 ⁷/₈ × 17 ¼ in. (227 × 438 mm) image
Edition: between 250—500
Published by Reed College Art Associates and the Reed Women's Committee, Portland, Ore.; the image is of the artist's 1986 pastel *The Geometry of Manet and the Sacred Heart*
1990.1.167

95.* Friends of the People, 1988

Etching, chine collé on white wove paper, 10/10
27 ³/₄ × 19 ³/₄ in. (705 × 503 mm) sheet; 8 ³/₄ × 7 ⁵/₈ in. (223 × 195 mm) image
Edition: 10
Published by the Illinois State University Art Department, Normal; printed by Ray George
1990.1.168

96.* Youth Orchestra Asian Tour '89, 1989

Color offset lithograph on white wove paper
26 ³/₄ × 18 ½ in. (681 × 471 mm) sheet and image
Edition: 1,000
Published by the San Francisco Symphony Youth Orchestra; printed by Tea Lautrec, San Francisco
1990.1.169

97.* Mother Jones, 1989

Color silkscreen on white wove paper, AP 1/13
30 × 22 ¹/₈ in. (764 × 563 mm) sheet; 25 × 19 in. (636 × 481 mm) image
Edition: 150; 13 APs
Published by *Mother Jones* magazine, San Francisco; printed by Jos Sances, Berkeley, Calif.
1990.1.170

98. Mary Harris "Mother" Jones, 1989

Color offset lithograph on white wove paper
18 ¼ × 13 ³/₄ in. (609 × 458 mm) sheet; 18 ¼ × 13 ³/₄ (463 × 350 mm) image
Edition: 2,000
Published by *Mother Jones* magazine, San Francisco; printed by Inkworks, Berkeley, Calif.
1990.1.171

99.* ¡Fuera de Panama! 1989

Color silkscreen on white wove paper
30 ¼ × 22 ¼ in. (766 × 565 mm) sheet; 25 ¹/₈ × 19 ¹/₈ in. (639 × 486 mm) image
Edition: 80; 50 for the Benefit of the Committee in Solidarity with the People of El Salvador and the Nicaraguan Information Center.
Published by the artist and Jos Sances; printed by Jos Sances, Berkeley, Calif.
1990.1.172

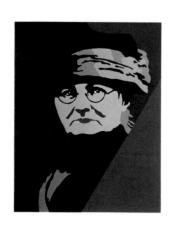

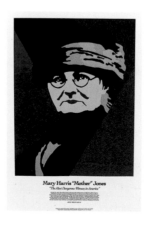

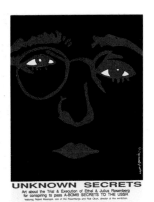
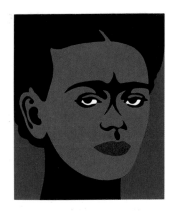

100.* Courbet and the Vendôme Column III, 1990

Color lithograph on Arches paper, 2/55
Diptych: 55 ³/₄ × 22 in. (1,410 × 563 mm) sheet and image; top, 28 ¹/₂ × 22 in. (711 × 563 mm); bottom, 27 ¹/₂ × 22 in. (699 × 563 mm)
Edition: 55
Published and printed by the Ernest F. De Soto Workshop, San Francisco; the image is of the artist's 1989 pastel of the same title
1990.1.173

101.* The Geometry of Manet and the Sacred Heart II, 1990

Color lithograph on Arches paper, 1/50
19 × 35 in. (485 × 898 mm) sheet and image
Edition: 50
Published and printed by the Ernest F. De Soto Workshop, San Francisco; the image is of the artist's 1986 pastel *The Geometry of Manet and the Sacred Heart*
1990.1.174

102. Unknown Secrets, 1990

Color offset lithograph on white wove paper
16 ¹/₂ × 10 ⁷/₈ in. (420 × 275 mm) sheet; 13 ⁷/₈ × 10 ⁷/₈ in. (352 × 275 mm) image
Edition: approx. 150
Published by Allen Barnett, San Jose State University, Calif.; the image derives from the artist's 1980 pastels *Ethel Rosenberg* and *Julius Rosenberg*
1990.1.175

103.* Frida Kahlo, 1990

Color silkscreen on Lenox 100 paper
30 × 22 in. (762 × 559 mm) sheet; 24 × 19 in. (610 × 482 mm) image
Edition: 100
Published by John X. Fernandez, Jr.; printed by Jos Sances, Berkeley, Calif.
1990.1.231

104. The Silver Dollar, 1990

Color silkscreen on white wove paper
White wove paper: 29 × 22 ³/₄ in. (737 × 567 mm) sheet; 25 ¹/₈ × 19 ¹/₄ in. (638 × 487 mm) image. Strathmore paper: 29 × 23 ¹/₈ in. (737 × 587 mm) sheet; 25 ¹/₈ × 19 ¹/₄ in. (638 × 487 mm) image
Edition: 200 on white wove paper; 20 other impressions on Strathmore Artist paper
Published by Ricardo López; printed by Jos Sances, Berkeley, Calif.; image from cat. no. 27
1990.1.232

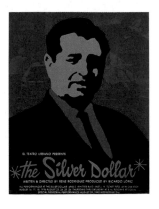

Biography

Born in French Camp, California, 1941

EDUCATION

Stockton College, Stockton, California. A.A., painting, 1962

San Francisco State College. B.A., painting, 1968. M.A., printmaking/silkscreen, 1970

University of California, Berkeley. Doctoral studies in art education, 1973–75

University of California, Berkeley. M.A., history of modern art, 1981

MILITARY SERVICE

United States Air Force, Air Police, U.S. and Indochina, 1962–66

TEACHING

San Francisco State University. La Raza Studies, 1969–77; Department of Art, 1970–81

San Francisco Art Institute. Department of Humanities, 1973–80

University of California, Berkeley. Chicano Studies, 1979–85, 1987; Department of Architecture, 1982–1985

Mills College, Oakland, California. Ethnic Studies, 1981

Washington State University, Pullman. Department of Comparative American Cultures, Department of Fine Arts, 1984

The Mexican Museum, San Francisco. Artist-in-Residence, 1986–88

Illinois State University, Bloomington. Visiting Artist, 1988

San Jose State University, San Jose, California. Associate Professor of Art, 1988–

RECENT GRANTS AND AWARDS

1987

Institute of Culture and Communication, East-West Center, Honolulu. Artist-in-Residence fellowship.

1988

San Joaquin County Arts Council, California. Honored as Distinguished Artist from San Joaquin County.

Board of Supervisors, San Joaquin County, California. Commendation as Distinguished Artist from San Joaquin County.

City of Stockton, California. Certificate of Recognition for Outstanding Contribution to the Arts.

California State Assembly. Resolution of Commendation for Career Achievement.

California State Senate. Resolution of Commendation for Distinguished Career as Painter.

Media Alliance, San Francisco. Meritorious Achievement Award in Graphics and Illustration.

1989

National Endowment for the Arts. Individual Artist Fellowship.

1990

California Arts Council. Artist Fellowship in Visual Arts.

COMMISSIONS

1989

San Francisco Symphony. Poster commission for San Francisco Symphony Youth Orchestra.

Mother Jones magazine, San Francisco. Commission for print.

SOLO EXHIBITIONS

1986

The Mexican Museum, San Francisco, *The Art of Rupert García: A Survey Exhibition*, 20 August–19 October. Catalogue.

1987

Galerie Claude Samuel, Paris, *Rupert García: New Pastel Paintings*, 3 March–4 April. Catalogue.

Institute of Culture and Communication, East-West Center, Honolulu, 1–31 July. Brochure.

Vollum Center Gallery, Reed College, Portland, Oregon, 20 September–1 November. Poster brochure.

MARS Artspace, Phoenix, Arizona, 5–31 October. Brochure.

1988

Iannetti-Lanzone Gallery, San Francisco, *Rupert García: New Work*, 14 January–13 February. Brochure.

The Haggin Museum, Stockton, California, *Distinguished Artist Series: Rupert García*, 17 January–21 February. Catalogue.

Saxon-Lee Gallery, Los Angeles, *The Art of Rupert García: Paintings and Pastels, 1986–1988*, 21 October–19 November. Brochure.

Galerie Claude Samuel, Paris, *Rupert García: New Work*, 24 November 1988–7 January 1989. Brochure.

1989

Zoo Galerie, Nantes, France, *Rupert García: Peintre Chican*, 25 May–1 July.

Hearst Art Gallery, St. Mary's College, Moraga, California, *Rupert García*, 3 September–1 October.

Iannetti-Lanzone Gallery, San Francisco, *Rupert García*, 14 September–21 October.

1990

Napa Valley College, Napa, California, *Rupert García*, 5 January–6 February.

Saxon-Lee Gallery, Los Angeles, *Rupert García: Apparitions and Emotions–Pastels 1983–1990*, 29 June–1 September.

RECENT GROUP EXHIBITIONS

1986

Watts Tower Arts Center, Los Angeles, *From Martin to Mandela: "The Struggle Continues,"* 19 January–16 March.

Museo Universitario del Chopo, Mexico, *Camino a Cuba*, 23 April–May. Brochure.

The International Art Fair, Basel, Switzerland, 12–17 June.

San Jose Museum of Art, San Jose, California, *Crossing Borders/Chicano Artists*, 19 July–24 August.

II Bienal de la Habana, Centro Wifredo Lam, Habana, Cuba, *Por Encima del Bloqueo*, November. Catalogue.

1987

De Saisset Museum, Santa Clara, California, *Speak: Social Serigraphy in the Bay Area, 1966–1986*, 17 January–15 March. Brochure.

National Museum of American Art, Smithsonian Institution, Washington, D.C., *Close Focus: Prints, Drawings and Photographs*, 4 September 1987–7 February 1988.

Monterey Peninsula Museum of Art, Monterey, California, *The Artist and the Myth*, 12 September–29 November.

Mission Cultural Center, San Francisco, *Images of Change*, 25 September–25 October.

1988

Museum of Modern Art, New York, *Committed to Print*, 27 January–19 April. Travel to: University Art Galleries, Wright State University, Dayton, Ohio, 30 October–15 December; Peace Museum, Chicago, 3 March–31 May 1989; Glenbow Museum, Calgary, Alberta, 23 September–19 November 1989; New York State Museum, Albany, 16 December 1989–11 February 1990; Spencer Museum of Art, University of Kansas, Lawrence, March–May 1990. Catalogue.

University Art Gallery, California State University, Stanislaus, *Cultural Diversity: Seven Americans*, 16 February–27 March.

Christian A. Johnson Memorial Gallery, Middlebury College, Middlebury, Vermont, *Recent American Pastels*, 28 February–1 May. Catalogue.

Art Museum of Santa Cruz County, Santa Cruz, California, *Mano a Mano:Abstraction/Figuration*, 17 April–5 June. Travel to: The Modern Museum of Art, Santa Ana, California, 8 October 1988–5 January1989; The Oakland Museum, Oakland, California, 4 March–30 April. Catalogue.

Metro Toronto Convention Center, Toronto, Ontario, Canada, *West: Art & the Law* (organized by The West Collection, St. Paul, Minnesota), 4–11 August. Travel to: Temple University, Philadelphia 26 August–15 October; Anderson Gallery, Virginia Commonwealth University, Richmond, 28 October–17 December; Rose Art Museum, Brandeis University, Waltham, Massachusetts, 22 January–26 February 1989. Catalogue.

Hillwood Art Gallery, Long Island University, Greenvale, New York, *Unknown Secrets: Art and the Rosenberg Era*, 9 September–23 October. Travel to: Massachusetts College of Art, Boston, 16 November–23 December; Olin Gallery, Kenyon College, Gambier, Ohio, 8 January–5 February 1989; Palmer Museum of Art, Pennsylvania State University, University Park, 19 March–14 May 1989; Art Gallery, University of Colorado, Boulder, 8 June–12 August 1989; Installation Gallery, San Diego, California, 8 September–22 October, 1989; Jewish Community Museum, San Francisco, 7 January–30 March 1990; Spertus Museum of Judaica, Chicago, 15 April–15 July 1990; Aspen Art Museum, Aspen, Colorado, 20 September–4 November 1990. Catalogue.

San Diego Museum of Art, San Diego, California, *Cultural Currents*, 9 July–4 September. Catalogue.

The Bronx Museum of the Arts, Bronx, New York, *The Latin American Spirit: Art and Artists in the United States, 1920–1970*, 29 September 1988–29 January 1989. Travel to: El Paso Museum of Art, El Paso, Texas, 27 February–23 April 1989; San Diego Museum of Art, San Diego, California, 22 May–16 July 1989; Instituto de Cultura Puertorriquena, San Juan, Puerto Rico, 14 August–8 October 1989; Center for the Arts, Vero Beach, Florida, 28 January–31 March 1990. Catalogue.

Works Gallery, San Jose, California, *Día de los Muertos*, 7–28 October.

Berkeley Art Center, *Peter Selz Selects: Seventeen Berkeley Artists*, 12 October–20 November 20. Catalogue.

Media Alliance, San Francisco, *Meritorious Achievement Awards Exhibition*, 1–7 November.

B-1 Gallery, Santa Monica, California, *Political Graphics*, 3–13 November.

Michael Dunev Gallery, San Francisco, *The Ties That Bind*, 25 November–3 December.

Iannetti-Lanzone Gallery, San Francisco, *Preview '89*, 2 December 1988–14 January 1989.

1989

The Mexican Museum, San Francisco, *Obras en Papel: Works on Paper*, 17 May–20 August. Brochure.

Iannetti-Lanzone Gallery, San Francisco, *Drawings: Part I*, 25 May–1 July.

Centre de Recherche pour le Developpement Culturel, Nantes, France, *Les Demons des Anges*, May/June. Travel to museums in Spain, Germany, and Sweden through July 1990. Catalogue.

Saxon-Lee Gallery, Los Angeles, 24 June–29 July.

Saxon-Lee Gallery, Los Angeles, *From the Back Room: Paintings, Drawings and Sculpture*, 5 August–2 September.

Whatcom Museum of History and Art, Bellingham, Washington, *A Different War: Vietnam in Art*, 19 August–12 November. Travel. Catalogue.

Gump's Gallery, San Francisco, *Artists of the Americas*, 25 September–28 October. Catalogue.

1990

The Oakland Museum, Oakland, California, *Oakland's Artists '90*, 24 March–1 July. Catalogue.

Chicago International Art Exposition, 1990 (Saxon-Lee Gallery, Los Angeles), Navy Pier, Chicago, 10–15 May. Catalogue.

Rena Bransten Gallery, San Francisco, *Works on Paper*, 24 July–16 August.

White Art Gallery, University of California, Los Angeles, *Chicano Art: Resistance and Affirmation, 1965–1985*, 9 September–9 December, Travel to: Denver Art Museum, 25 January–18 March 1991; Albuquerque Museum, 7 April–9 June 1991; San Francisco Museum of Modern Art, 27 June–25 August 1991; Fresno Art Museum, Fresno, California, 21 September–24 November 1991; Tucson Museum of Art, 19 January–5 April 1992; National Museum of American Art, Washington, D.C., 7 May–25 July 1992. Catalogue.

(For exhibitions before 1986 see Ramon Favela, *The Art of Rupert García* [San Francisco: Chronicle Books and The Mexican Museum, 1986].)

Bibliography

Books

Albright, Thomas. *Art in the San Francisco Bay Area, 1945–1980.* Berkeley: University of California Press, 1985.

Barnett, Alan W. *Community Murals.* Philadelphia: The Art Alliance Press, 1984.

Bierman, Wolfgang. *Frieden und Umwelt.* Bonn: Der Initiative fur Frieden, Internationalen Ausgleich und Sicherheit (IFIAS), 1988.

Goldman, Shifra M., and Tomás Ybarra-Frausto. *Arte Chicano: A Comprehensive Annotated Bibliography of Chicano Art, 1965–1981.* Berkeley: Chicano Studies Library Publications Unit, University of California, 1985.

Hopkins, Henry, and Jim McHugh. *California Painters: New Work.* San Francisco: Chronicle Books, 1989.

Orr-Cahall, Christina. *The Art of California: Selected Works from the Collection of the Oakland Museum.* Oakland: The Oakland Museum Art Department; San Francisco: Chronicle Books, 1984.

Catalogues

Berkson, Bill. *Rupert García.* Stockton, California: The Haggin Museum, 1988.

Butler, Jim. *Recent American Pastels.* Middlebury, Vermont: Middlebury College, 1988. Ill.: "Prometheus Under Fire," 1984.

Cancel, Luis R., et al. *The Latin American Spirit: Art and Artists in the United States, 1920–1970.* Bronx, New York: The Bronx Museum of the Arts; New York: Harry N. Abrams, 1988. Ill.: "Zapata," 1969.

Castellon, Rolando. *Mano a Mano: Abstracción/Figuración.* Santa Cruz, California: The Art Museum of Santa Cruz County and University of California, Santa Cruz, 1988. Ill.: "Yankees," 1987; "Reds Against the Nazis," 1987.

Catlett, Elizabeth. *Rupert García/Pastel Drawings.* San Francisco: San Francisco Museum of Modern Art, 1978. Ill.: "Lucio Cabanas," 1976; "Mexico, Chile, Soweto," 1977; "Political Prisoner," 1976; "Inez García," 1975/77.

Centro de Estudios Económicos y Sociales del Tercer Mundo. *A Través de la Frontera.* Mexico, D.F., 1983.

Charlot, Jean. "Posada and His Successors," in *Posada's Mexico.* Washington, D.C.: The Library of Congress, 1979.

Chicago International Art Exposition, 1990. Chicago: Chicago International Art Exposition, 1990. Ill.: "Los Espíritus de Diego y Frida," 1988.

Favela, Ramon. *The Art of Rupert García.* San Francisco: Chronicle Books and The Mexican Museum, 1986.

Galería de la Raza. *Homenaje a Frida Kahlo.* San Francisco, 1978.

García, Rupert, et al. *Other Sources: An American Essay.* San Francisco: San Francisco Art Institute, 1976. Ill.: "Political Prisoner," 1976.

Garrigan, John (intro.), et al. *Images of an Era: The American Poster 1945–75.* Washington, D.C.: National Collection of Fine Arts, Smithsonian Institution, 1976. Ill.: "Attica is Fascismo," 1971; "Libertad para los Prisoneros Políticas!," 1971.

Hong Kingston, Maxine, Jean Charlot, and Angela Davis. *Rupert García.* Honolulu: East-West Center, Institute of Culture and Communication, 1987. Ill.: "Libertad para los Prisoneros Políticas,"1971; "Homenaje a Frida Kahlo," 1978; "Maguey de la Vida," 1973; "Zapata," 1969; "Picasso," 1973.

Hopkins, Henry T. Intro. *The Human Condition: SFMMA Biennial III.* San Francisco: San Francisco Museum of Modern Art, 1984.

Letellier, Pascal, et al. *Les Demons des Anges.* Nantes: Centre de Recherche pour le Developpement Culturel, 1989.

Lippard, Lucy. *Por Encima del Bloqueo.* Havana, Cuba: II Bienal de la Habana, 1986.

———. *A Different War: Vietnam in Art.* Bellingham, Washington: Whatcom Museum of History and Art/The Real Comet Press, 1989. Ill.: "Fenixes" (cover and p. 64), 1984.

Monteverde, Mildred. *Chicano Gráficos ... California.* Pueblo, Colorado: Southern Colorado State College, 1975.

Navarrette, Diego A., Jr., et al. *Raíces Antiguas/Visiones Nuevas.* Tucson, Arizona: Tucson Museum of Art, 1977. Ill.: "The Bicentennial Art Poster," 1976.

O'Connor, Francis V. "The Influence of Diego Rivera on the Art of the United States during the 1930s and After" in *Diego Rivera: A Retrospective.* Detroit: Detroit Institute of Arts; New York: W. W. Norton, 1986.

The Pollution Show. Oakland, California: The Oakland Museum, 1970.

Selz, Peter. *Rupert García.* San Francisco: Harcourts Gallery, 1985.

———. *Rupert García: New Pastel Paintings.* Paris: Galerie Claude Samuel, 1987.

———. Intro. *Peter Selz Selects: Seventeen Berkeley Artists.* Berkeley, Calif.: Berkeley Art Center, 1988. Ill.: "Confrontation," 1988.

Wye, Deborah. *Committed to Print: Social and Political Themes in Recent American Printed Art.* New York: Museum of Modern Art, 1988. Ill.: "El Grito de Rebelde," 1975.

Brochures

Ballard, Robert H. *Rupert García: New Work.* San Francisco: Iannetti-Lanzone Gallery, 1988. Ill.: "Yankees," 1987.

Chabot College. *Cinco de Mayo I.* Hayward, California, 1976.

Davis, Angela. "On the Art of Rupert García" in *Rupert García.* Phoenix, Arizona: MARS Artspace, 1987. Ill.: "Goliath and David: The Invasion of Grenada," 1987.

Franco, Jean. *Juan Fuentes y Rupert García: Posters-Drawings-Prints.* San Francisco: Galería de la Raza, 1975.

García, Rupert. *Rupert García: New Work.* Paris: Galerie Claude Samuel, 1988.

Hernandez, Jo Farb. *The Artist and the Myth.* Monterey, California: Monterey Peninsula Museum of Art, 1987.

Lewallen, Constance. *Rupert García: Matrix/Berkeley 79.* Berkeley, California: University Art Museum, 1984.

Macias, Elva. *Camino a Cuba: Donación de Artistas Plásticos Norteamericanos al Pueblo de Cuba.* Mexico City: Museo Universitario del Chopo, 1986.

The Mexican Museum. *Rupert García: Portraits/Retratos*. San Francisco, 1981. Ill.: "Assassination of Striking Mexican Worker," 1979.

Rossman, Michael. "The Evolution of the Social Serigraphy Movement in the San Francisco Bay Area, 1966–1986," in *Speak: Social Serigraphy in the Bay Area: 1966–1986*. Santa Clara, California: De Saisset Museum, 1987.

Saxon-Lee Gallery. *The Art of Rupert García*. Los Angeles, 1988. Ill.: "Manet-Fire," 1987; "Erupting Iranian Platform," 1988; "Fiesta Goya," 1988.

University of Minnesota, Coffman Memorial Union. *Poster and Silkscreen Art of Rupert García*. Minneapolis, 1980.

Weber, John S. *Rupert García*. Portland, Oregon: Reed College, 1987. Poster brochure. Ill.: "The Geometry of Manet and the Sacred Heart," 1986.

Articles

Alarcon, Francisco X., Juan Felipe Herrera, and Victor Martinez. "Portraits Plus Struggles Plus Consciousness: Nine Pastels by Rupert García." *Metamorfosis* 3, no. 2 (1980) and 4, no. 1 (1981).

Alba, Victoria. "Artists with a Mission." *Image* (S. F. Examiner), 20 May 1990, pp. 22–31. Ill.: The Artist with "El Día de la Raza, or the Cristobal Enterprise," 1989; "Las Tres Mujeres," 1988; "For Harry and Malcolm," 1988; "For Magritte," 1988; "Camisa Maximilian," 1988.

Albright, Thomas. "A Print Show Tiny, but Solid." *San Francisco Chronicle*, 19 December 1973. Ill.: "Orozco."

———. "An Art Show That Began with a Toilet." *San Francisco Chronicle*, 21 December 1974, p. 30.

———. "At the Galleries." *San Francisco Chronicle*, 27 May 1975.

———. "The Force of Universals." *Artnews* 77, no. 0 (Summer 1978), pp. 174–175.

———. "Anonymous Martyrs and Geometric Lobby Decor." *San Francisco Chronicle*, 26 January 1981, p. 44.

———. "The Sunny Outlook of Rufino Tamayo." *San Francisco Chronicle*, 23 June 1983, p. 57.

———. "Rupert García: Radical Political Portraitist." *San Francisco Chronicle*, 28 April 1983, p. 60

———. "Letting the Art Fit the Crime." *S.F. Sunday Examiner & Chronicle*, 18 March 1984, "Review" section, pp. 12–13.

"Art: Christopher Lane/Rupert García." *California* 13, no. 1 (January 1988), pp. 14–15. Ill.: "The Snow in Frida Kahlo," 1986.

"Arte de Dos Culturas se Exhibe en la Lotería Nacional." *Novedades* (Mexico), 15 September 1987, "Sociales" section, p. 1.

"Artes de la Raza." *Artweek* 1, no. 29 (5 September 1970).

Atkins, Robert. "Mexican Geometrics and Political Portraits." *San Francisco Bay Guardian*, 4–11 February 1981, p. 14.

B., E. "Die Strasse als Galerie: Plakatkunst der Chicanos aur Zeit im Kulturtreff in der Helmstrasse." *Erlanger Tagblatt*, 20–21 May 1982.

Baker, Kenneth. "García Pastels Treat Art as Ammo." *San Francisco Chronicle*, 12 September 1985, p. 58. Ill.: "For Caravaggio and ALB," 1985.

———. "A Mixed Bag of Berkeley Art." *San Francisco Chronicle*, 26 October 1988, p. E3.

———. "Drawings Suggested by News Hot Spots." *San Francisco Chronicle*, 4 October 1989, p. F3.

Baker, Lori. "Outrage: García's Artworks Celebrate his Politics and Champion Civil Rights, Social Causes." *Metro Phoenix* 22, no. 12 (December 1987), pp. 75–76. Ill.: "Cambios," 1972; "¡Cesen Deportación!," 1973; "¡Fuera de Indochina!," 1970.

Barrack, Mark. "MARS Schedule Features Array of Stars." *Arizona Business Gazette*, 7 September 1987, sec. B, p. 4. Ill.: Photo of the artist with "Goliath and David: The Invasion of Grenada," 1987.

Berkson, Bill. "San Francisco: Rupert García." *Artforum* 25, no. 4, December 1986, p. 122. Ill.: "Mascaranica," 1985.

Berlin, Mark. "Portraits and Politics: García at the UAM Matrix." *The Berkeley Voice*, 12 December 1984, p. 18. Ill.: "Une Enigme/A Riddle," 1984.

Bishop, Crisse. "Recent American Pastels." *Campus* (Middlebury College, Middlebury, Vermont), 26 February 1988, pp. 10–11. Ill.: "Prometheus Under Fire," 1984.

Bonetti, David. "The Hispanic Vision." *San Francisco Examiner*, 2 October 1989, p. C1 and C3.

Burkhart, Dorothy. "Protest Art from García." *San Jose Mercury News*, 14 December 1984, p. 14D. Ill.: "Une Enigme/A Riddle" (detail), 1984.

———. "Violence Colors Artworks: 'Crime and Punishment' Attacks Urban Epidemic." *San Jose Mercury News*, 9 March 1984, pp. 1D & 2D. Ill.: "Assassination of a Striking Mexican Worker," 1979.

———. "Critics' Choice." *San Jose Mercury News*, 15 September 1985, "Arts and Books" section, p. 20. Ill.: "Nose to Nose," 1985.

———. "The Art of Politics." *San Jose Mercury News*, 1 February 1987, "Arts & Books" section, pp. 16–17.

———. "Portraits of a Culture: Hispanic Artists Make Presence Known in Show." *San Jose Mercury News*, 6 May 1988, pp. 1E & 13E. Ill.: "Yankees," 1987.

Burnson, Patrick. "Rupert García in Major Show." *People's World*, 21 September 1985, p. 10. Ill.: "For Caravaggio and ALB," 1985.

"Chicano Artist Helps Gallery Raise Funds." *Arizona Arts*, September 1987, p. 76.

"Chicano Renaissance." *San Francisco Focus*, September 1986, p. 127.

Christensen, Judith. "Disparate Influences, Shared Attitudes." *Artweek* 19, no. 27, 6 August 1988, p. 8. Ill.: "Rufino Tamayo," 1983.

"55 Obras de Rupert García en Mexican Museum." *People's Daily World*, 10 October 1986, p. 25A.

Cohn, Terri. "Expressions of Commitment." *Artweek* 17, no. 32, 4 October 1986, p. 9. Ill.: "Mascaranica," 1985.

Curtis, Cathy. "A Rather Grim Picture of Latino Art from S.F." *Los Angeles Times*, 5 December 1988.

Dangle, Lloyd. "Graphics and Illustration: Rupert García." *Mediafile* (San Francisco) 14, no. 5 (October/November 1988), pp. 10–11. Ill.: "Attica is Fascismo," 1971; "Prometheus Under Fire," 1984; "Mascaranica," 1985; "Diego Rivera," 1984; "Political Prisoner," 1976.

de Lappe, Pele. "From Pen to U.N.: Saga of Rupert García's Poster." *People's World*, 11 July 1981, p. 10. Ill.: "Free Nelson Mandela" (poster), 1981.

Ernst, Margo. "García's Social Comments Still Sharp as Ever." *Stockton Record*, 7 September 1986, pp. F1 & F8. Ill.: "Carnival of War," 1985.

_____. "Paris Gallery Toasts Rupert García's Art." *Stockton Record*, 29 March 1987, pp. F1 & F9. Photo of the artist. Ill.: "For Joaquín Murieta and Rosita?," 1986.

_____. "A Stockton-Raised Artist Brings Vivid Vision Back 'Home'." *Stockton Record*, 17 January 1988, pp. F1 & F3. Ill.: "Aflame Man and Orange Horse," 1987; "For Tía Juana y Mi Abuelita Guadalupe de Jalostotitlan," 1987.

"Exposición Mexico-Norteamericana Mexicana en la Lotería Nacional." *Novedades* (Mexico), 8 September 1987, p. 11.

Frankenstein, Alfred. "When Politics and Art Do Mix." *San Francisco Chronicle*, 15 March 1978, p. 53. Ill.: "Political Prisoner," 1976.

_____. "An Intimate Look At a Leading Mexican Artist." *San Francisco Chronicle*, 7 November 1978, p. 52. Ill.: "Frida Kahlo."

"Galleries: Portrait of the Artist." *San Francisco Focus* 35, no. 1 (January 1988), p. 84.

Geer, Susan. *Los Angeles Times*. 18 August 1989, p. 17.

Glowan, Ron. " 'A Different War': Battlegrounds in the Mind." *Artweek* 20, no. 29 (9 September 1989), pp. 1 and 8. Ill.: "Fenixes," 1984.

Gray, Virginia. "Interior Motives." *Los Angeles Times Magazine*, 19 March 1989, pp. 29–37. Ill.: "Manet-Fire," 1987.

Greene, Jim. "Fine Art Welcomes Rupert García." *The News* (San Jose State University) 6, no. 1 (Fall 1988), p. 14.

Hackett, Regina. "Museum Braves an Art-World Untouchable— Vietnam." *Seattle Post Intelligencer*, 30 August 1989.

Harris, R. J. "García's Portraits Explode Off the Walls." *The Potrero Hill View* (San Francisco), February 1981, p. 5. Ill.

Hatch, Nita. "Art Articulus: Rupert García Receives Distinguished Artist Recognition." *Lincoln Center Chronicle* (Stockton, California) 13, no. 5 (January 1988), pp. 5 & 23. Ill.: "Ominous Omen," 1987.

Hiner, Mark. "Vietnam Art Show Painful, Beautiful." *The Western Front*, 13 October 1989, p. 10.

Hong Kingston, Maxine. "Rupert García: Dancing Between Realms." *Mother Jones* 14, no. 8 (October 1988), pp. 32–35. Ill.: "Ominous Omen," 1987; "Zapata," 1969; "Carnival of War," 1985; "Mascaranica," 1985; "Aflame Man and Orange Horse," 1987.

"Inauguraran una Muestra Pictórica de Valores Mexicanos con Aire 'Chicano'." *El Sol de Mexico* (Mexico), 8 September 1987, p. 2.

"Inauguro Rodriguez y Rodriguez la Expo de Arte Mexico-Norteamericana." *Excelsior* (Mexico), 17 September 1987, p. 18.

Kimmelman, Michael. " 'Latin American Spirit' Has Admirable Goals." *New York Times*, 30 September 1988, p. B8.

"Latin American Themes Showcased in New Exhibit." *Santa Cruz Sentinel*, 15 April 1988, p. 14.

Levin, John. "San Francisco's Mexican Museum." *Travel & Leisure*, May 1987, pp. CA18–CA22.

Lippard, Lucy. "Whatcom Museum Offers First Major Exhibition of American Artwork Influenced by Vietnam War." *Northwestern Events & Lifestyle Review* 3, no. 8, (September 1989), p. 10.

Marvel, Bob. "Rupert García: Personalized Politics." *La Voz* (Seattle, Washington), June–July 1985, p. 26. Ill.: "Olga Tamayo," 1983; "Never Again," 1984; "Vincent," 1980.

Mesa-Bains, Amalia. "Contemporary Chicano and Latino Art." *Visions* 3, no. 4 (Fall 1989), pp. 14–19. Ill.: "Fiesta Goya," 1988.

"Mexico-Norteamerica, una Muestra Pictórica en la Lotería Nacional." *El Nacional* (Mexico), 8 September 1987, p. 6.

Moreno, E. Mark. "Rupert García." *Access* (San Jose State University) 3, no. 1 (Fall 1988), pp. 7–9. Ill.: "El Grito de Rebelde," 1978; "Reds Against the Nazis," 1987; "Assassination of a Striking Mexican Worker," 1979.

Morse, Marcia. "Artistic Messages." *The Sunday Star-Bulletin and Advertiser* (Honolulu), 14 June 1987, p. F9. Ill.: "Libertad para los Prisoneros Políticas," 1971.

Obenland, Kathleen. "Visiting Prof Makes Statements in Art." *Daily Evergreen* (Evergreen, Washington), 21 February 1984, p. 3. Ill.: "Mexico, Chile, Soweto."

Obshaarsky, Darlene. "Alum's Art Show Cast Light on Vietnam War." *Resume*, Fall 1989.

"A Personal Statement in Silkscreens and Pastels." *Honolulu* 22, no. 1 (July 1987), p. 20. Ill.: "Picasso," 1970.

Pflaum, David. "Political Portraiture: Rupert García's Posters and Pastels." *Daily Californian*, 29 April 1983. Ill.: "Vincent," 1980; "Assassination of a Striking Mexican Worker," 1979.

Pincus, Robert L. "Museum of Art Exhibit is an Ethnic Mix." *San Diego Union*, 21 July 1988, pp. D1 & D7. Ill.: "Rufino Tamayo," 1983.

"Portrait of the Artist." *San Francisco Focus* 35, no. 1 (January 1988), p. 84.

Ronck, Ronn. "Back When the Poster Was a Message of the Times." *The Honolulu Advertiser*, 25 June 1987, p. C3. Ill.: Photo of the artist.

" 'Rufino Tamayo' Pastel by Rupert García ..." *San Jose Mercury News*, 15 August 1986, p. 16D. Ill.: "Rufino Tamayo."

"Rupert García Expone." *El Mundo* (Oakland, California), 21 January 1988, p. 5. Ill.: "Yankees," 1987.

Samson, Kevin. "Art Museum Will Present Work of Mexican American Painters." *Santa Cruz Sentinel*, 14 April 1988, pp. D1 & D3.

San Francisco Focus 36, no. 9 (September 1989), p. 157.

Saville, Jonathan. "Original Thirteen." *Reader* (San Diego, California) 17, no. 31 (11 August 1988).

Seymour, Ann. "The Vision of San Francisco." *San Francisco Magazine* 2, no. 5 (May 1988), pp. 32–37, 124. Ill.: "Goliath Over David or the U.S. Invasion of Grenada," 1988.

Tamblyn, Christine. "San Francisco: Rupert García/ Christopher Lane." *Artnews* 87, no. 4 (April 1988), p. 164. Ill.: "The Geometry of Manet and the Sacred Heart," 1986.

Timmons, Grady. "Rupert García: A Different Kind of Political Prisoner." *Centerviews* (Honolulu), June–July 1987, pp. 1 & 3. Ill.: Photo of the artist. "Picasso," 1970.

Turner, Nancy Kay. "The Fire This Time." *Artweek* 19 no. 38 (12 November 1988), p. 6. Ill.: "Manet-Fire," 1987.

Ugarte, Abdon. "Poster de E. Zapata para El Publico." *La Prensa* Year 3, no. 62, July 1969, pp. 1–2. Ill.

"U.S.A.: Chicanos en las Paredes." *El Comercio* (Lima, Peru), 13 May 1979, Suplemento dominical, p. 10. Illustration of mural design by Rupert García in Chicano Park, San Diego, California, 1978.

Van Proyen, Mark. "Metaphor and Ideology." *Artweek*, 22 December 1984, p. 3. Ill.: "Never Again," 1984.